# Medieval Enamels

## MASTERPIECES FROM THE KEIR COLLECTION

MARIE-MADELEINE GAUTHIER
and
GENEVIÈVE FRANÇOIS

edited and translated
by
NEIL STRATFORD

British Museum Publications Limited

© Abbas Establishment 1981

ISBN 0 7141 1358 1

Published by British Museum Publications Limited
46 Bloomsbury Street, London WC1B 3QQ

British Library Cataloguing in Publication Data

Gauthier, Marie-Madeleine
Medieval enamels masterpieces from the Keir Collection.
1. British Museum – Exhibitions – Catalogs
2. Keir Collection  3. Enamel and enameling – Limoges –
Exhibitions – Catalogs
I. Title   II. François, Geneviève
III. Stratford, Neil
738.4'0944'66     NK5024.F/

ISBN 0–7141–1358–1

Designed by Norman Ball

Printed in Great Britain
Composition in Sabon by Filmtype Services Limited,
Scarborough, North Yorkshire
Text printed by Pindar Print Limited, Scarborough,
North Yorkshire
Plates printed by Henry Stone Limited, Banbury, Oxford

# Medieval Enamels

Medieval Enamels

# CONTENTS

Preface *by Neil Stratford*      6

Introduction      7

The Catalogue      12

Concordance      37

List of Abbreviations      38

List of Exhibitions      38

Bibliography      38

The Plates      41

# PREFACE

BY NEIL STRATFORD

This catalogue is published to coincide with an exhibition, to be held in the British Museum from 29 October 1981 until late January 1982. Because the gallery space available is limited, it has only been possible to exhibit some fifty objects. These are here numbered to follow the sequence adopted in the showcases. The selection of objects has been dictated by their historical interest, their artistic quality, or both. They were chosen from what is in fact a much larger and overall remarkable collection; this was formed between the early 1950s and the mid-1960s by Ernst and Martha Kofler-Truniger, of Lucerne. In 1971 the whole of the Kofler-Truniger collection of enamels was sold; it numbered at that time 156 pieces or groups, but this figure includes a few bronzes, sculptures and post-medieval painted enamels (see the Kofler collection catalogue, 1965). The purchaser, who has since added some twenty pieces, wishes the collection to be known as The Keir Collection. He has now with great generosity lent this small and choice selection of enamels for exhibition with an express desire to make them available, even if only for a short period, to the interested public.

The collection can be counted among the half dozen most important in the field of medieval Limoges. It therefore seemed logical to mount an exhibition of Limoges, whilst a few of the best enamels from other regions (e.g. Mosan, Upper Rhenish), of various periods and in a variety of techniques are exhibited in a parallel showcase as counterpoint to the main theme, which is concerned with the development of the medieval Limoges enamellers. Who better qualified to catalogue this material than Madame Marie-Madeleine Gauthier? The first volume of her *Corpus* of Limoges enamels is soon to appear under the auspices of the Centre National de Recherche Scientifique after long years of preparation. In the writing of this catalogue she has been ably assisted by Mademoiselle Geneviève François. I would like to thank them both most warmly for their contri-

bution, which goes far beyond the writing of the catalogue itself; all aspects of the exhibition have been discussed with them at every turn. Particularly remarkable is the new information they have unearthed on the provenance of several pieces, discovered by dint of long research on early sale catalogues. Their notices place a special emphasis on the enameller's technique, and on the individual character imparted to each particular object by the distribution of the coloured glasses. Any visitor to the exhibition who reads a catalogue entry in front of the object itself will be able to move a long way towards an understanding of its make-up. The production of Limoges, superficially a consistent tradition, becomes infinitely subtle and varied under Madame Gauthier's selective guidance. Certain notices have been largely prepared by Monsieur Philippe Coudraud, who also works with the *Corpus* team; these are acknowledged (P. C.). The four Mosan enamels are catalogued by myself and acknowledged (N. S.); for the sake of consistency I have adopted the same system of entry which Madame Gauthier employs for the rest of the collection. Dr Michael Rogers of the Department of Oriental Antiquities has assisted with the catalogue entries for nos. 44 and 45, and my colleague in the Department of Medieval and Later Antiquities, Mr John Cherry, translated the heraldic terms under nos. 35 and 36. Finally, I would like to thank another colleague, Mrs Katherine East, for her invaluable help with the presentation of the bibliography and for many other tasks related to the preparation of this catalogue.

For the publication it was decided to re-employ the excellent colour and black-and-white blocks which were originally made for the 1965 Kofler collection catalogue. The reader is therefore warned that illustrations are not reproduced to scale; reference must always be made to the dimensions as given in the Notices.

N. S.

# INTRODUCTION

BY MARIE-MADELEINE GAUTHIER

A small selection of medieval enamels from the Keir collection is on exhibition in the British Museum for a period of some three months. The exhibition can be seen in the Medieval Gallery, where the cream of the national collection is already presented to the public. This is therefore a rare occasion. Of the two collections being shown side by side, one is the product of centuries of British collecting, the other only recently formed, although remarkably complete in itself. A small chapter of history has here been written out of a close co-operation between scholar and collector: the objects are small in scale, the exhibition narrowly defined in its aims, yet it is perhaps not unjustified to claim a certain kinship with the great exhibitions of the Victorian period or of the Second Empire. For, just as at South Kensington in 1862[1] and at the Trocadéro in 1865 and 1867,[2] the comprehension of what constitutes a work of art has been the principal aim, and the means employed have been the latest research on the documents and on the objects themselves from a technical and stylistic point of view. The fruits of this often unpublished research are presented here in the catalogue.

The great nineteenth-century exhibitions were heavily subsidised and universal in scope, bringing together works of art of every kind, whatever their date and cultural origin. For instance, the London exhibition of 1862 was virtually an inventory of the artistic heritage of the United Kingdom, with contributions from the landed families, the Empire, from connoisseurs and the Church, from societies of charitable status or from civic communities. In Paris in 1867, on the other hand, the exhibition commissioners drew on national museums, as well as the private collector, simply because by that date France, like several other countries in Europe, had already for several decades been taking over the aristocratic '*Kunstkammern*' and the treasures of the Church.[3] The provinces also played their part: in Great Britain there were similar great exhibitions at Manchester in 1857, at Liverpool in 1811, 1854, 1876, 1877, and at Edinburgh in 1856.[4]

The introductions to the catalogues of these exhibitions make it abundantly clear that presentation of the works of art had a particular aim, over and above the more general desire to educate the public, for it was at the workers, especially the craftsmen and artists, that they were directed. Born out of a politics of social and economic optimism, they aimed to create not only aesthetic pleasure but also a stimulus in purely practical terms. Technical virtuosity was still admired and sought after without any suggestion that it might run counter to the true spirit of artistic invention: that ideology of art was to be propounded later. Now, after two World Wars and all the other experiences of our own twentieth century, we look upon things in a very different light, though there have been certain gains. These medieval enamels for instance, those of the national collection and of this international private collection, are now valued even more highly for what they can teach us. They are, in short, better known and better cared for.

The nineteenth-century exhibitions stood already within an existing tradition of the study of medieval art. An exhibition held in Paris in 1979, *Le Gothique retrouvé*,[5] has recently underlined the creative rôle that England played in the Gothic Revival from well back into the eighteenth century,[6] for pragmatic observation and the historical interpretation of the works of past centuries have long been established in England. This small exhibition in 1981 therefore seems to me very much in line with the experimental English scholarly tradition: a number of works of art are being studied and exhibited together, all technically of one limited category and all produced within a single region, Romanesque Aquitaine if not, as is very probable, in a single town, Limoges.

Already by the end of the eighteenth century, Richard Gough, an extremely knowledgeable historian of medieval metalwork, was attributing to Limoges the remarkable *champlevé* enamels which were submitted by Fellows at meetings of the Society of Antiquaries of London. The two most extraordinary pieces were the *châsse* from

Malmesbury and the Thomas Becket *châsse*, probably from Peterborough, which has recently been placed on loan in the British Museum and is exhibited in Case 4 of the Medieval Gallery. But long before Gough, others had been interested in the technique or the subject-matter of these enamels, many of which had already been for centuries in England; what is more, early and very judicious opinions were expressed about their chronology.[7] But so far no evidence has come to light that there was any exchange of scholarly views in the eighteenth century as between the Society of Antiquaries and local historians in the Limousin, for instance with the abbés Nadaud and Legros, or the abbé de Voyon, who were corresponding in France with Du Cange and with the abbé d'Expilly.[8] Only in the 1830s and 1840s was the way opened up, with a rewarding correspondence between Albert Way and the abbé J. T. Texier (1813–59), who was resident at the seminary of Le Dorat in the Limousin and owned the *châsse* of St Valerie and St Martial, catalogued here as no. 32. Texier produced an inventory which began with his own region but developed a European scope, bearing fruit in his indispensable *Dictionnaire d'orfèvrerie*.[9] Way, for his part, worked on the graphic and textual sources, and knew the English collections well; in 1845 he referred to a celebrated contract in which Walter de Merton, Bishop of Rochester (1272–7), orders his tomb from the enameller, John of Limoges.[10] Somewhat earlier, in 1836, there was another important publication: in *The Gentleman's Magazine*, Samuel Meyrick described in full the collection bequeathed to him by his friend Francis Douce, a collection which later came to the British Museum.[11]

It was therefore in England that, in the course of the seventeenth and eighteenth centuries, humanists patiently began the process of recovering their medieval past. Unwittingly they were contributing to a major shift in artistic taste: in their efforts to repair the damage done by the iconoclasts of Henry VIII's reign, they were already preparing the way for the 'érudition romantique' in France. For, some two centuries after them, the Antiquaires de France also began to reconstruct the history of their church treasures, broken up relatively recently during the French Revolution. In Paris at the time of the Restoration of the Monarchy, first in 1825 through the collector Edme Durand, then in 1828 with the painter Pierre Révoil, a group of thirty-one Limoges enamels, among several hundred other pieces, came to the 'Musée des Souverains'. This was to become the nucleus of the future Département des Objets d'Art of the Louvre. To quote only two examples, it was at this time that the Louvre was given the famous ciborium (inv. M.R.R.98), which Révoil asserted to have been found in the course of works carried out at the Abbey of Montmajour in Provence; its celebrated inscription, MAGI(S)TER G. ALPAIS ME FECIT LEMOVICARUM, stands as a key document in the history of medieval enamelling, even if the interpretation of the inscription in terms of philology and date remains a delicate problem.[12] Secondly, the beautiful plaque with the Dormition of the Virgin, which has been most generously lent to this exhibition by the Louvre, so that it can once again be reunited with the two gable-shaped plaques (no. 10 and Fitzwilliam Museum, Cambridge M31–1904), also comes from Révoil's collection. Pierre Révoil, scholar and 'peintre troubadour', had his English counterpart in another painter, Gambier-Parry, who saved the wall-paintings in several English medieval churches.[13] He too acquired a number of Limoges enamels, which are today divided between the Gallery of the Courtauld Institute, London, and the National Gallery, Washington.

In all European countries, during the period between about 1790 and 1920, there is a common denominator: the liturgical vessels and reliquaries, whether of enamel, precious metals or ivory, passed in large numbers from the church treasuries into the museums. This generalisation is true, however much the history of one country may differ from another. Treasures belonging to the church or to the great families tended to end up during this long period of almost continuous strife as part of the larger public collections. To be sure, they were often for short periods in the safekeeping of private individuals; private collectors would assume responsibility for what was in effect and had been since the Middle Ages our common heritage.[14] On the other hand, the heritage of the Roman Catholic Church is a special case: it is still to this day housed in the Vatican, but it has always been at the command of each successive Pope, whilst remaining the collective property of the Holy See, looked after by one or more of the Cardinals. Among its treasures is a superb plaque, enamelled with the Resurrection of Adam. Already in the Museo Sacro Vaticano before 1874, it comes from a very large lost cross, made at Limoges about 1180, of which the British Museum possesses two of the three other terminals, with the Virgin Mary and St John. These are exhibited here with the fourth terminal, a plaque with two censing angels (no. 2 in this catalogue).[15]

The wish to establish a 'national' museum had already been born in Poland by 1775, with the break-up of the kingdom. This initiative came from the Princess Isabelle Czartoryski, who collected together various pieces which were no longer in use or had been set aside in church treasuries, for example, the Limoges crozier from the Franciscan Convent at Lwów, formerly in Poland (in German:

Lemberg).[16] Her descendants and their family circle emigrated, first to London, then on to Paris, among them the Countess Dzialinska and, much later, the princes Zamoïski. This Polish family can be numbered among the great pioneer collectors of medieval Limoges.[17] One of their compatriots, the sculptor Mark Antokolsky, who was born in Wilna in 1842 and died in Paris in 1901, followed in their footsteps – see no. 10 catalogued here.

It is to another great figure that we owe no. 19, the statuette of the Virgin Mary enthroned, which comes from Old Castille. Antoine-Marie-Philippe-Louis of Orleans, duke of Montpensier, was the fifth son of Louis-Philippe, born at Neuilly in 1824 and dying at Seville in 1890. His wife was Marie-Louise of Bourbon, the sister of Queen Isabella II of Spain. Whether through financial or worldly pressure, he succeeded in acquiring the Keir statuette from a Spanish cleric into whose hands it had come after 1836, when the Abbey of San Pedro de Arlanza, near Burgos, was secularised. The scholarly repercussions of this purchase were to be felt much later, here in England, for it helped to spark off the well-known hypothesis proposed by Hildburgh: to Castille he attributed an entire group of these enamelled 'ymages' of the Virgin and Child.[18] He based his claim on three main arguments. First, he pointed out just how many of the early enamels survived in the north Spanish treasuries: these were of a type which was still at that time thought to be early Limoges. Secondly, he isolated as Spanish a particular technical feature, the way that these statuettes were constructed out of two shells of metal (as is e.g. no. 19). Thirdly, he fixed on a decorative motif, the *vermiculé* scroll, as having a Moorish origin (cf. nos. 1, 2). Today his argument has lost much of its validity. For instance, to take only the first point, work on the *Corpus* has revealed a very widespread distribution of Limoges in the Middle Ages: not only in France but also in Belgium, England, Scandinavia, Poland and Russia, there is evidence for the presence of early enamels in treasuries by the twelfth or thirteenth centuries. This does not of course argue against the ultimately southern French origin of the enamellers.

Nevertheless Hildburgh made a major contribution to the debate about the origins of Limoges. The term 'oeuvre de Limoges' could no longer be taken at face value. It has now become accepted as a useful formula covering a number of possibilities and applying either to the place of manufacture, or to the place where the artists were trained, or to the style and techniques they employed, or to the place from which the enamels were exported, or even finally to the place where the coloured glasses used in the enamelling process were produced. One or more of these possibilities is no doubt correct. But when all is said and done, one fact remains, that in the Middle Ages as today a Limoges enamel had certain generic features which were immediately recognisable to the spectator.[19] In compiling the catalogue of some ten thousand surviving pieces, I therefore preferred to employ a wider and less apparently precise, in fact less loaded term than Limoges, one that could be seen to take account of all these various possibilities: the *Corpus des émaux méridionaux*. This title is broad enough to embrace transfers and trade in these objects, and in the raw materials, glasses and copper, as well as the circulation of models which is suggested by the consistent repertoire of the figures and the decorative motifs, and all this over a long period from about 1100 to 1350. As to this trade and movement of objects and of artists, the Pyrenees played a critical role, first in the period from about 1115–80,[20] and then again about 1320–40. We can chart in this exhibition the cardinal importance of Catalonia in the later period: a highly original plaque with the 'cosmic' Crucifixion (no. 52) is here remarried with its cross, which has been in the British Museum since 1895.[21]

Elsewhere in Europe in the nineteenth century, aristocratic collections of Limoges were being formed. There was the *Kunstkammer* of the Kings of Prussia, which was later to become the nucleus of the Kunstgewerbe Museum in Berlin. Or again, the Hohenzollern family at Schloss Sigmaringen had already collected before 1877 not only fragments of Rhenish or Mosan *châsses*, but also thirty-one pieces of Limoges. The collection was broken up in 1928 and we have not yet completed the task of tracing all the pieces.[22] It may be that some of them can be identified with items in the Keir collection but my co-author Geneviève François has preferred to postpone publication of such identifications until our work on the old sale catalogues is complete.

For the last two years the team which is working on the *Corpus des émaux méridionaux* has been systematically extracting information from old sale catalogues[23] and much new evidence has been unearthed about the more recent history of pieces in the exhibition. Among the more important or famous collectors before the Second World War, whose names will be found in the catalogue, are: the abbé J. Texier (no. 32), the abbé Julien Gréau (nos. 10, 37), Johannes Paul (no. 16), Octave Homberg (nos. 10, 21), Raoul Heilbronner (no. 7), J. Larcade (nos. 29, 30), D. Schevitch (nos. 4, 25, 52), the Liechtenstein family (nos. 22, 35), Georges Chalandon (nos. 6, 8, 26, 38, 48, 54), Adolphe Stoclet (nos. 1, 47, 49), the comtesse de Béhagues (no. 37), Philip Nelson (nos. 37, 41). For unlike the banker J. Pierpont Morgan who was able to leave to the Metropolitan Museum, New York, a great

collection of enamels which he had largely purchased *en bloc* at the Paris sale of the Hoentschel collection in 1911,[24] Ernst and Martha Kofler-Truniger, who collected virtually all the pieces in this exhibition, bought the objects one at a time: from about 1950 onwards, they collected through dealers and at sales, and not only medieval enamels but also ivories. In 1965, their collection was first exhibited to the public in an exhibition at the Suermondt-Museum at Aachen, organised by Hermann Schnitzler and Peter Bloch.[25]

With the Aachen exhibition Schnitzler and Bloch were adding a link to a distinguished chain. They were following in the footsteps of men like Darcel, Molinier or Marquet de Vasselot who, by cataloguing private collections at the end of the nineteenth century, made a major contribution to scholarship.[26] The present catalogue is very much in the same tradition, the results of collaboration between private collectors and scholars. Neil Stratford, our editor, proposed that the opportunity should be taken to publish here the latest research on Limoges by the *Corpus* team. The Centre National de Recherche Scientifique in Paris has sponsored the *Corpus* since its first steps were taken at Limoges in 1948 and during its subsequent years in Paris. It is with the blessing of the CNRS that the information in this Catalogue is now made available. Since it was London that took this new initiative, I would also wish to recall that it was from London that the first photographs were offered to the *Corpus*: they were provided during the memorable exhibition in the Musée Municipal de Limoges in 1948[27] by the former Keeper of the Department of Metalwork in the Victoria and Albert Museum, Charles Oman, and by the late William King, Deputy Keeper of the Department of British and Medieval (now Medieval and Later) Antiquities in the British Museum.

As to the present catalogue entries, they are organised according to a new system, which has been worked out over a long period and which I believe to be applicable to any portable *objet d'art*. The principal aim is to facilitate comparison with any other object of similar type, by arranging the information in simple categories: first materials and construction, then technique, then the colours and their distribution, then subject-matter and finally style. The entries are the result of twenty years of research by the small group who have worked for the *Corpus*. I would particularly wish to mention Marie and Madeleine Beaure d'Augères, Simone Thiébault, Simone Caudron, Michèle Bilimoff and Philippe Coudraud. The latter has been involved in the final drafting of some of the entries and on these occasions his work has been acknowledged (P. C.).

The *Corpus des émaux méridionaux* is now on

the point of beginning its publication. There are to be five volumes, and this catalogue presents material from the whole range of the forthcoming volumes, ordered historically and on the basis of a series of already published articles and studies. As to the exhibition itself, the central area of five showcases has been arranged to tell the story of the stylistic and technical evolution of Limoges. The changing forms and varying approach to colour speak for themselves in this respect. Here I will simply content myself by underlining the particular importance of some of the exhibited pieces. What was the original function and provenance of no. 21, the remarkable standing figure of a young man holding a scroll? We do not know, but stylistically he certainly belongs to an early and creative phase of Limoges. As to no. 13, if I am correct in identifying the enigmatic scene on the front of this little *châsse* as the Judgement of Solomon, then we may go rather farther and postulate that it could be a very rare example of an object made to contain relics relating to the Hebrew scriptures. No. 19, the Virgin and Child statuette, is of great interest for the surprising rôle that it came to play in battle. The exhibition of no. 10 in London has created the opportunity to show it alongside its 'pair' from the Fitzwilliam Museum, Cambridge, and another plaque, very probably from the same large *châsse*, in the Louvre. With firmly drawn silhouettes, the interior modelling of the figures is massively conveyed by grids of lines engraved across the gilded surfaces of the draperies: here is a highly original 'Style 1200'. Indeed, throughout the exhibition it is possible to pinpoint the changing approaches of the enameller at different stages in history. Take, for instance, his approach to the selection and distribution of his coloured glasses. How severely controlled it is before about 1180, how harmonious from about 1180 to 1200, how repetitive from 1220 to 1260, and finally how simplified from the last third of the thirteenth century onwards. What is more, workshops or the individual artists can be recognised by the way that the different colours are juxtaposed. For this reason, the colours are not always listed locally in this catalogue. One could almost describe them employing terms from the language of music, in an attempt to characterise the mixed fields in which several colours are fired as in a 'scale', some of greater, some of lesser visual importance. Blue can be considered the 'dominant' when edged with white, or green when edged with yellow, whilst accents of red or black are the 'tonic'. Where these standard keys are varied, as if by accidentals, we can measure the artist's performance: they can be a sign of remarkable virtuosity (no. 10), or of an original touch; they can be simply a mistake, sometimes even the hallmark signalling a real

change in taste (no. 37). These multi-coloured 'scales' act to harmonise the two other controlling colours, the background blues and the gilding of the reserved areas. It is through the particular distribution of colours that each object takes on a character of its own.

Finally, one small showcase in the exhibition has been given over to other types of medieval enamel, which can thus be compared in technique with the Limoges pieces. There are groups of gold *cloisonné* (nos. 42–4), of copper *cloisonné* (nos. 45–6) and of Mosan copper *champlevé* enamels (nos. 47–50). In addition, from the fourteenth century, there are *champlevé* enamels from Catalonia (no. 52), Italy (no. 55) and the Upper Rhineland (no. 51), which are all quite different from the contemporary Limoges production, not only in their subject-matter but also in technique: an unusual red and a deep blue take over the backgrounds or fill the engraved lines of the flesh parts and the draperies, or the copper plaque is treated as if it were silver, punched and enamelled in *basse-taille* (no. 53). This is also the period when the technique of the Limoges enameller begins to be dissociated from metal 'sculpture', as seen in the small statuettes almost in the round which stand nearly free of the enamelled grounds (no. 38).

Thus, rich as the Keir collection is in Limoges, it can also offer a small conspectus of many other branches of medieval enamelling.

M. -M. Gauthier

NOTES: 1. London Exhibition 1862.
2. Paris Exhibition 1865; *Musée rétrospectif*, Paris 1867.
3. De Linas 1867.
4. Exhibition, *Manchester Art Treasures*, Manchester 1857; Catalogue, *The Exhibition of the Liverpool Academy*, 1811; A. Way, *Catalogue of Antiquities exhibited at the meeting of the Archaeological Institute*, Edinburgh 1856.
5. Grodecki 1979, especially sections VI, VII, enamels nos. 196, 197, 208–10, 212–17, 229–34.
6. Clark 1928; Frankl 1960; Carey 1979, section I, 17–27.
7. Caudron 1976 and 1977.
8. Du Cange 1678; d'Expilly 1762–70.
9. Texier 1857; Pacand 1956.
10. Oxford, Bodleian Library, Ms. Cod. Ballard 46, published in Way 1845, 171. This document was also known to the Limoges scholar, the abbé Legros (Legros 1775, 105), and is the subject of a study by J. R. L. Highfield (Highfield 1954), which was kindly brought to my attention via Claude Blair by his son, William John Blair.
11. Meyrick 1836, 100; 'Doucean' medieval Limoges enamels in the British Museum, MLA 78, 11–1, 1–12; *Bodleian Quarterly Record*, 7 (for 1932–4), Oxford 1935, 359–82.
12. Gauthier 1976.
13. Chaudonneret 1980, 107–47 (Révoil); editorial 'A Great Victorian' in *The Burlington Magazine*, CIX, for March 1967 (special edition on the Gambier-Parry collection); and Blunt 1967.
14. Babelon *et al.* 1980.
15. Stohlman 1939, 31–2 (cat. 516), figs. 17–19, pl. v.
16. Formerly collections Princess Czartoryski, Prince Lubomirski; now Lwów museum, USSR (Marquet de Vasselot 1941, cat. 188).

17. Molinier 1903. Several objects in the collection were purchased at the Germeau sale, Hôtel Drouot, Paris, 6–7 May 1868; cf. also *Corpus*, vol. III, a Limoges group with the Entombment, Minneapolis Institute of Art (Molinier 1903, cat. 149); see also the Mosan enamelled cross, Kötzsche 1977, cat. 550.
18. Hildburgh 1936 and 1955. See also Rupin 1890, 459–73.
19. Gauthier 1958a, 1958b; see also Gauthier 1957.
20. Gauthier 1978b, 1967a and 1963.
21. François 1981.
22. Lehner 1872, *passim*; *Kurzes Verzeichnis der im staedelsen Kunstinstitut, ausgestellten Sigmaringen Sammlungen*, Frankfurt-on-Main, 1928, 36–40 (at this date, only twenty-one Limoges pieces exhibited).
23. Abstracts for *Corpus* made from sale catalogues by F. Arquié since 1978.
24. A. Peraté, *Collection Georges Hoentschel*, II, *Emaux du XIIe au XVe siècle*, Paris 1911.
25. Aachen exhibition 1965; see also Kofler collection catalogue.
26. Darcel and Basilewsky; Molinier 1903 and prefaces to the catalogues of the Boy sale (Galerie Georges Petit, Paris, 15–24 May 1905) and the D. Schevitch sale (Galerie Georges Petit, Paris, 4–7 April 1906); J. J. Marquet de Vasselot, *Catalogue raisonné de la collection Martin le Roy*. I, *orfèvrerie et émaillerie*, Paris 1906.
27. *Emaux limousins XIIe, XIIIe, XIVe siècles*, catalogue of 164 entries by M. -M. Gauthier, exhibition Musée Municipal, Limoges 1948.

TRANSLATOR'S NOTE – certain French terms are common currency and have therefore been used here, e.g. *repoussé*, *cloisonné*, *champlevé*, *châsse*, *cabochon*, *vermiculé*, *basse-taille*, *de plique*.

# 1  Châsse, with Christ in Majesty and Apostles (plates 1–2).

*Champlevé enamel on copper. H. 16.9cm; W. 22.6cm; D. 8.2cm. Limoges, about 1190–1200.*

Casket, with pitched roof (cresting lost) and gabled ends, on four cubical feet. Six copper plaques cover a wooden core: (a) front – eighteen pinholes; (b) roof front – sixteen pinholes; (c) back – nineteen pinholes; (d) roof back – sixteen pinholes; (e) and (f) left and right gable ends – nine pinholes each. Copper sheets *champlevé*, enamelled, engraved, chased and gilded. Enamel: cobalt blue, azure blue; red, green, turquoise; yellow, white; in single or mixed fields of up to four colours (red-yellow-green-blue, red-cobalt blue-azure-white). On the front and ends, decoration and draperies of main figures enamelled, the borders of the fields punched, the heads applied and not yet of classical type, the grounds *vermiculé*, the lesser figures reserved and engraved, the framing borders with little reserved crosses on an enamelled ground. On the back, diaper pattern part enamelled, part reserved, the borders of the field punched.

The front, (a), is divided into three areas. In the middle Christ in Majesty, enthroned on the rainbow in a mandorla and flanked by the four Evangelist symbols, blesses with his right hand and holds a book in his left hand; his mantle is cobalt blue set off with turquoise, over a green tunic set off with yellow, the hem blue and red. The spandrels are cut horizontally by a multi-coloured 'cloud' band. Top left, the winged man of St Matthew gestures towards Christ; top right, the eagle of St John with scroll; bottom, the lion of St Mark and the calf of St Luke, both with books, are addorsed, their heads turned back towards Christ. In the two side fields a standing Apostle, nimbed, beneath an arcade, with cobalt blue mantle over azure blue tunic; both are turned towards Christ, one with a book in his covered left hand, while his right hand points towards the ground, the other with a red book held in both his hands.

On the roof, (b), five three-quarter-length Apostles stand beneath arcading holding books or scrolls in their right or left hands; their cobalt blue mantles set off with azure are worn over either a green tunic set off with yellow or an azure tunic with red collar. On the back, (c)–(d), a cobalt blue ground decorated with a diaper of rows of eleven discs, each enclosing a curved lozenge (alternately red-blue-white and red-green-yellow). On the ends, (e)–(f), beneath a round-headed arch capped by a little turret, a standing figure with speckled blue nimbus, turned towards the front of the *châsse*: the left saint has a cobalt blue mantle set off with turquoise, over a green tunic set off with yellow, and carries a flowering staff in his left hand; his counterpart wears a cobalt blue mantle set off with green over an azure and white tunic, while his right hand is raised and his left hand holds a book.

The *vermiculé* decoration is close-knit but formed in rather irregular patterns. The draperies are divided into small areas, some with a reserved 'dot' of metal in them. The use of edging colours isolates each area of the draperies from its neighbour, thus reducing any effect of bulk the garments might have. The applied heads are characterised by large noses, 'domed' hairstyles which leave the ears visible, drooping beards and moustaches. All these features, as well as the little turrets above the arcades, can be found on the *châsse* in the Treasury of the Cathedral of Auxerre.[1]

P. C.

PROVENANCE: before nineteenth century, in a Spanish monastery (not identified); before 1905, private collection, Madrid; before 1965, Stoclet collection, Brussels; after 1965 to 1971, Kofler collection; 1971–, Keir collection.

LITERATURE: Marquet de Vasselot 1906, 24 (no. 19, at that time in Madrid); Philippe R. Stoclet Sale, Sotheby, London, 27 April 1965, lot 30, col. pl.; Kofler collection catalogue E 156, pls. 90–92; Aachen exhibition 1965, cat. E 156, pls. 78–80; Gauthier 1966a, 943–51, C. 32, pls. I–III; *Corpus*, vol. I, G–4, 2 (ph. 8143–6, 12981–4).

NOTE: 1. *Corpus*, vol. I, G–4, 3.

# 2  Rectangular plaque: two censing angels (plate 3).

*Champlevé enamel on copper. H. 10.9cm; W. 22cm. Limoges, about 1185–90.*

Top terminal from the front of a very large cross. The other three terminals survive as:

(b)  bottom terminal, Adam (Museo Sacro Vaticano, 516 (inv. 895)). H. 14.9cm; W. 22.2cm (photograph exhibited)

(c)  left terminal, Virgin Mary (BM, MLA 50, 7–22, 5). H. 21.7cm; W. 10cm

(d)  right terminal, St John (BM, MLA 50, 7–22, 6). H. 21.8cm; W. 10cm

No. 2 has twenty pinholes, regularly distributed. Centre of lower edge cut down. On the back is an incised mark: a small spiral motif ending in a closed hook. Copper plate, with enamelled figures, the edges of the fields punched, on a reserved, engraved and gilded ground; the border enamelled with reserved punched decoration. Enamel: translucent lapis blue, ultramarine blue, pale blue, turquoise, green, red, yellow, white, in single or mixed fields. Two censing angels, half-length with haloes, emerge from clouds. They turn towards the centre and look downwards, their censers swung between them. One holds a scroll, the other gestures with his left hand open, a witness of the Godhead. Both wear a blue mantle over a green dalmatic, edged with yellow and with an orphrey neckband. Their wings are spread and enamelled within long or smaller fields, in a variety of colours: two blues, turquoise, white, red and green, distributed differently on each wing. The gold ground is engraved with an unhatched spiral *vermiculé* pattern, of the highest technical accomplishment. The border, enamelled blue, dots of white set within a reserved motif of simple but regular double knots of interlace.

Terminals (b), (c), (d) have the same colour range, *vermiculé* grounds and interlace borders, the latter unique to these four plaques. In spite of slight differences in dimensions and in the number of pinholes, there

can be no doubt that all four plaques come from the same object. Terminals (c) and (d) have both been cut down on their inner edge only, at the point where they joined the main arms of the cross, which were part of the same copper sheet and from which they projected. The original height of the horizontal cross arms was 15.1cm. A similar cut on the lower edge of (a) corresponds to the width of the vertical cross arm (15.5cm). On terminal (b), Adam, naked, raises the cover from his tomb. This cover is too small and the wrong shape to have fitted over the tomb chest, which is shown with an irregular trapezoid opening; cover and opening are enamelled green edged with yellow and bordered with deep blue dotted with red. The false perspective effect is heightened by the contrast between these deep colours and the brilliant turquoise of the sides of the tomb. The tomb chest is raised on a row of little arches, of various colours, its side decorated with diagonal fields and gilded quatrefoils. Adam's body is schematised, the reserved lines punched and gilded, the flesh a cold white, set off against the dark blue of the hair and beard. The lively spirals of the *vermiculé* patterns form a contrasting background to the taut figure of Adam beneath the weight of his tomb cover. Terminals (c) and (d) show the Virgin and St John, standing on hillocks, their large many-coloured haloes touching the upper borders. The Virgin is in three-quarter profile, her hands in the gesture of an orant, her feet together and shown in profile, framed tightly by the border. St John supports a book within his crossed arms, his weight on his left leg, his right foot advanced and cutting the frame.

The exceptional size of the plaques implies a cross of monumental scale, probably as much as 5 ft. high. Their technical perfection and homogeneity of execution suggest the work of a master enameller, whose style can be found later within the group from the High Altar of the Abbey of Grandmont (Haute-Vienne). As to the Matutinal Altar at Grandmont, it is known that it carried a cross which was of much the same monumental size as that from which these four plaques come, but there can be no question of identifying this as our missing cross[1]. Terminal (b) was almost certainly in the de Théis collection which was formed in Limoges between 1830 and 1833.[2]

PROVENANCE: *Angel Plaque*: 1847–50, Debruge-Duménil collection, Paris; 1850–65, Pourtalès-Gorgier collection, Paris; 1865, acquired by Beurdeley from the Pourtalès sale for 780 F.; 1906, Stieglitz museum, St Petersburg; 1933, Brimo collection, Paris; before 1960 until 1971, Kofler collection (inv. 650 S); 1971–, Keir collection.
*Adam Plaque*: 1830–33, an analogous plaque is catalogued by Adolphe de Théis, son of Baron Alexandre, prefect of the Haute-Vienne. A learned young scholar and collector of *champlevé* and painted enamels, he lived in Limoges and was the author of 'une petite classification sur les anciens émaux incrustés', in which the plaque in question is considered as one of the oldest pieces of evidence for Limoges enamelling (cf. Ardant 1855, 46). Was Adolphe de Théis the owner of the piece or had he merely seen it? 1867, the plaque makes its first appearance in an inventory of the Vatican museum (de Montault 1867, 78).
*Virgin Plaque*: before 1850, S. P. Cox collection (it does not appear in the catalogue of the Debruge-Duménil collection); 1850, purchased by the dealer Webb (Christie's, London, 8–9 July) and acquired from Webb by the British Museum.
*St John Plaque*: 1847–50, Debruge-Duménil collection, Paris; 23 January 1850, bought by Mawson from the Debruge-Duménil sale for 405 F.; July 1850, acquired by the dealer Webb (Christie's, 8–9 July) and from Webb by the British Museum. October 1981, three of the

four plaques reunited for the first time since the dismemberment of the cross.

LITERATURE: *Angel Plaque*: Labarte 1847, 572–3, cat. 664; Debruge-Duménil sale, auctioneer Bonnefons de Lavialle at the Jeuneurs, Paris, 23 January 1850, cat. 664; Pourtalès-Gorgier sale, 7 rue Tronchet, Paris, 6 February 1865, cat. 1748; Marquet de Vasselot 1906, 44 (mentioned) and 36; Stohlman 1939, 32, fig. 19; Cologne exhibition 1960, cat. 85; Zürich exhibition 1964, cat. 843, pl. 88 (Reviews: Demoriane 1964, 195; Kauffmann 1964, 315; Lasko 1964, 468); Kofler collection catalogue E 37, pl. 11; Aachen exhibition 1965, cat. E 37, pl. 64; Souchal 1967, 63–7, fig. 35; *Corpus*, vol. I (ph. 4120, 6580–81).
*Adam Plaque*: Ardant, 1855, 46–7; de Montault 1867, 78, no. 354; Mgr X. Barbier de Montault, *Oeuvres complètes*, II, Poitiers, 1889, 210, no. 354; Rupin 1890, 431; L. Boudery, 'L'orfèvrerie et l'émaillerie limousines au Vatican', *BSAHL*, XLVII, 1899, 381, no. 895 and 383, no. 1 (after the abbé Stornaiolo's manuscript catalogue, ed. G. B. Rossi, Rome, 1893); Marquet de Vasselot 1906, 36; Stohlman 1939, 31–2, pl. V; Souchal 1967, 63–7, fig. 34; Gauthier 1972, ch. 3 (Grandmont); M. Courtault, 'La collection du baron de Théis', Mémoire de maîtrise d'histoire de l'art et d'archéologie, Université de Paris IV Sorbonne, 1980–81 (in preparation); *Index of Christian Art*, Princeton University, USA: 43/R 76/LVT/P 3, 6: Adam, resurrection 027536; *Corpus*, vol. I (ph. 12571).
*Virgin Plaque*: British Museum acquisitions register 1850, 7–22, 5; Ch. de Linas, 'La châsse de Gimel (Corrèze) et les anciens monuments de l'émaillerie', *BSSHA de la Corrèze*, V, 1883, 131; Marquet de Vasselot 1906, 35–6 and 44, pl. VIII; Stohlman 1939, 31–2, fig. 17; Cologne exhibition 1960, 57, 85; Zürich exhibition 1964, under cat. 843; Kofler collection catalogue, p. 20; Aachen exhibition 1965, p. 51; Souchal 1967, 63–7, fig. 33; *Corpus*, vol. I (ph. 455, 8319).
*St John Plaque*: Labarte 1847, 572, cat. 663; Debruge-Duménil sale, cat. 663; J. Labarte, *Histoire des arts industriels au moyen-âge et à l'époque de la Renaissance*, album II, Paris 1864, pl. CX; further bibliography as for the Virgin Plaque (Stohlman 1939, fig. 18; *Corpus*, vol. I (ph. 455, 8318)).

NOTES: 1. Souchal 1967; Gaborit 1976, 231–46, figs. 1, 2.
2. M. Courtault, *La collection du baron de Théis* (see bibliography Adam plaque, above).

---

# 3  Cross (plate 2).

*Champlevé enamel on copper. H. 17.7cm; W. 11cm. Limoges, about 1180–85.*

---

Circular crossing and curved terminals, two holes at base of shaft, two groups of pinholes for two lost applied figures, one larger than the other. Single copper sheet, 35mm thick, the front simply gilded, the back *champlevé*, enamelled, engraved and gilded (areas of damage around the holes and near the base of the shaft). Spike cut down. Enamel: cobalt blue, azure blue; red, grass green, rich green, black; yellow; white; in single or mixed fields, up to a range of four tones, dominated by blue or green. Decoration reserved, with punched and serrated patterns, then enamelled, against an enamelled ground. Front: *titulus* – IHS/above XPS, for *Ihesus Christus*;[1] the original Christ figure is lost. Border, with a succession of circles. Back: the crossing has an irregularly lobed green octofoil behind a blue and red flower, whose centre is a delicately hatched reserved quatrefoil and whose four graceful petals spiral outwards into the arms of the cross. Each arm is filled with an intricate pattern of branches, reserved and gilded against a deep blue ground: two stems interlace and form heart-shaped areas joined by little punched and gilded discs; within

each area is a flower with green and blue petals, facing towards the centre of the cross.

This type of foliage decoration is found on the *châsse* of Ambazac, of 1182,[2] and on two book-covers, one in the Pierpont Morgan Library, New York, the other in the Louvre, where angels alternate with these flowers.[3] No. 3, however, is outstanding among the Limoges crosses of the last decades of the twelfth century[4] for the refined quality of its decoration; it is a unique piece.

P. C.

PROVENANCE: before 1964 to 1971, Kofler collection (inv. 661); 1971–, Keir collection.

LITERATURE: Zürich exhibition 1964, cat. 888 (Reviews: Demoriane 1964, 95; Kauffmann 1964, 15; Lasko 1964, 468); Kofler collection catalogue E 94, pl. 22; Aachen exhibition 1965, cat. E 94, pl. 75; *Corpus*, vol. I (ph. 6537–8).

NOTES: 1. F. Hospital, 'Les inscriptions sur les croix dans l'oeuvre de Limoges', *102e Congrès National des Sociétés Savantes*, Limoges, 1977, 21–35.
2. Gaborit 1976, 231–46.
3. Migeon 1904, fig. p. 39; Gauthier 1968, 283, no. 7, fig. 2; *Corpus*, vol. I, F 4, 4 (New York), vol. I, F 4, 7 (Paris, Louvre).
4. *Corpus*, vol. I, C 3, 1–10; H 4, 1, 2, 12–17.

## 4 Châsse, with the Holy Women at the Tomb (plate 4).

*Champlevé enamel on copper. H. 20.9cm; L. 17.7cm; W. 9.1cm. Limoges, about 1185–95.*

Casket, with pitched roof and gabled ends, on four cubical feet. Eight copper plates cover an oak core (red protective paint layer still visible inside the roof). There is a door in the back, with keyhole and close-set pins. Cresting, pierced alternately with rosettes, horseshoe arches and quatrefoils; three crowning projections. Copper plates *champlevé*, engraved, chased, enamelled and gilded. Enamel: light blue, ultramarine blue, azure blue; red, green, black; turquoise; yellow; white, in single fields, or set off against each other. Reserved figures, chased and with applied heads of classical type (on the front only), the enamelled grounds studded with chased and enamelled motifs, the borders of their fields punched. Interior of casket lined with eighteenth-century printed paper and red silk.

On the front (bottom), the Holy Women at the Tomb: carrying ointment jars, they approach a small arched building with a dome and two turrets, on the right a seated angel with furled wings points to the empty sarcophagus and the winding-cloth; the side of the tomb is decorated with a multi-coloured strigil pattern. The background blue is of a deeper tone within the most sacred area, around the tomb. On the front (roof) three figures emerge from clouds within quatrefoils: Christ, arms extended and holding a cross and a book, flanked by two saints, each with a book; there is a turquoise band behind the saints, the grounds deeper blue within the quatrefoils, ultramarine blue in the spandrels, which are studded with enamelled discs with chased star motifs. Borders have a blue 'cloud' motif and punched reserved patterns. On the gable-ends, a saint stands

beneath a turreted arch, the grounds blue with turquoise horizontal band and multi-coloured rosette discs. On the back, diaper of squares with multi-coloured quatrefoils, blue or green against a turquoise ground.

The Visit of the Holy Women to the Tomb is found associated with various other scenes or with purely geometric decoration: by about 1175–80 on the *châsse* in the church of Nantouillet (Seine-et-Marre)[1], in the period 1190–1220 on a whole series of Limoges *châsses* (e.g. Musées Royaux d'Art et d'Histoire, Brussels (v. 2064); Bibliothèque Municipale, Amiens (L'escapolier 23)[2]). No. 4 is probably among the earliest surviving *châsses* decorated with enamelled background fields: see the still 'Romanesque' treatment of the draperies, the *vermiculé* decoration of the feet on the front.

PROVENANCE: before 1890, G. Vermeersch collection, Brussels; before 1906, Schevitch collection; before 1960 to 1971, Kofler collection (inv. 670 Q); 1971–, Keir collection.

LITERATURE: Rupin 1890, perhaps identical with the *châsse* in Belgium described on p. 424; Schevitch sale, Galerie Georges Petit, Paris, 4–7 April 1906, lot 178, pl. p. 142; Cologne exhibition 1960, cat. 94, pl. 79; Zürich exhibition 1964, cat. 833, pl. 87; Kofler collection catalogue E 7, pls. 9, 31; Aachen exhibition 1965, cat. E 7, pl. 62; *Corpus*, vol. II (ph. 4570–73, 6520).

NOTES: 1. *Corpus*, vol. I, G l, 3.
2. *Corpus*, vol. II; see also A. Jansen, *Musées royaux d'Art et d'Histoire. Art chrétien jusqu'à la fin du Moyen Age*, Brussels 1964, cat. 107, pl. XLV.

## 5 Châsse, with Christ in Majesty and the Crucifixion (plate 5).

*Champlevé enamel on copper. H. 20.3cm; W. 16cm; D. 8.5cm. Limoges, about 1195–1200.*

Casket, with pitched roof and gabled ends, on four square feet. Cresting, pierced with two series of five horseshoe arches and with three lozenges, two crowning crystals (modern?). Wooden core covered with seven copper plates (originally eight: on the back, plaque to left of door lacking). Enamel: four blues; green, red, black, turquoise; yellow; white; in single fields or mixed, up to a range of four colours dominated by green or blue with red or black accents. Reserved figures, chased, the heads applied separately and of classical type (on the front only); the enamelled grounds traversed by horizontal enamelled bands and studded with decorative motifs either reserved or enamelled, the borders of the fields punched with a variety of patterns, the feet *vermiculé*. On the front (bottom), central, almost square field showing the Crucifixion: Christ crowned on a green cross, the Virgin and St John standing on either side. Two narrower side fields with 'cloud' borders, each with a saint seated on a turquoise band within a mandorla. On the front (roof), three nearly square fields, the side fields with 'cloud' borders: Christ crowned, blessing and holding a book, flanked by two saints emerging from clouds within quatrefoils. On the two gable-ends, a standing saint in a mandorla, traversed by three horizontal turquoise bands, the grounds studded with gilded and multi-coloured discs or

rosettes, the borders with a motif of little crosses. On the back, a diaper of gilded and enamelled discs, dominated by green or blue; gilt crosses between, regularly spaced; the colour-scheme arranged in a regular diagonal layout.

Certain features are typical of a very productive and successful Limoges workshop, which was active from about 1190 to 1215: the Crucifixion is juxtaposed with a Christ in Majesty; gilded figures are set in mandorlas against intense blue grounds; mandorlas, circles or quatrefoils are studded with small chased star-like discs (cf. the discs which on certain crosses replace the personifications of *Sol* and *Luna*). The narrative element is wholly absent, dogma is conveyed through a series of serene visions: hence the impossibility of identifying the saint for whose relics the *châsse* was made. This workshop is closely related to Master G. Alpais (see Introduction, note 12). Many *châsses* of this series were originally to be found in church treasuries, e.g. at Klosterneuburg, near Vienna (Klepsia 1 and 3); Pisa, Opera del Duomo (no. 119); St Michael, Siegburg, near Bonn; Villemaur (Aube), a priory of Grandmont, etc.[1]

P. C.

PROVENANCE: before 1964 to 1971, Kofler collection (inv. 670); 1971–, Keir collection.

LITERATURE: Zürich exhibition 1964, cat. 832, pl. 86; Kofler collection catalogue E 6, pls. 8 and 30; Aachen exhibition 1965, cat. E 6, pl. 61; Gauthier 1966*b*, 24, 25, fig. 124; *Corpus*, vol. II (ph. 4559–62, 6521).

NOTE: 1. *Corpus*, vol. II.

# 6 Bookcover, with Crucifixion (plate 6).

*Champlevé enamel on copper. H. 31.8cm; W. 19.1cm. Limoges, about 1200.*

Wooden core, decorated with copper plaques. In the recessed central area is a rectangular plaque (H. 24cm; W. 11.3cm) with ten pinholes (an eleventh was pierced later through Adam's head). On the sloping inner edges of the frame are four strips of *repoussé* copper with settings for six oval *cabochons*, of which two survive. On the outer border are four rectangular plaques, each with eight pinholes (top and bottom plaques: H. 2.6cm; W. 19.1cm; side plaques: H. 27.5cm; W. 2.5cm). Enamel: cobalt blue, azure blue; red, black, green, turquoise; yellow; white; in single fields or mixed, with a range of blues or greens, up to four colours. Figures engraved, chased and gilded, on enamelled grounds with multi-coloured decorative motifs, the borders of their fields punched.

Christ crucified, with cross nimbus and four nail-holes, set on a green cross standing on a multi-coloured enamelled mound. His head is inclined on his right shoulder, his arms slightly bent at the elbows, his wrists sharply bent. There is a slight twist of the abdomen, the stomach is defined by a central furrow, the loincloth knotted on his left hip, the footrest azure blue with white-red spots. Titulus IHS/XPS, for *Ihesus Christus*,

beneath the hand of God blessing from a cloud. Below, Adam rises from the tomb. Flanking the cross, the Virgin Mary and St John on two multi-coloured mounds. The Virgin grasps her left hand in her right in a gesture of sorrow, while St John holds a book in his right hand, his left held open in a gesture of witness. Two nimbed three-quarter length angels emerge from clouds above the cross. They are also bearing witness to the scene; one holds a scroll, the other a book. The background is cobalt blue, interrupted by two turquoise horizontal bands and by a constellation of discs and rosettes, which are enamelled in pairs alternately in a blue or a green range. The upper and lower borders of the Crucifixion are decorated with a 'cloud' motif (white – two blues – red) and punched scrolls on a gilded ground. On the inner edges of the frame are engraved lozenges enclosing punched circles. On the outer frame are twelve fields with reserved angels against deep blue grounds, who make a variety of gestures, their haloes of green-yellow enamel, the clouds blue-white. The angels alternate with larger fields of ultramarine blue enamel, each decorated with a double foliage scroll and two flowers, one of blue, one of green tone. There is an absolute clarity in the layout of the colours, for instance in the contrast between the gilded and enamelled areas or between the blues and greens; cf. the cover of a Gospel-book (Giannalisa Feltrinelli collection, Cologny-Geneva), which can be attributed to Master G. Alpais.[1] These book-covers belong to a characteristic Limoges group of about 1200.

P. C.

PROVENANCE: before 1890 to 1893, Frédéric Spitzer collection, Paris and G. Chalandon collection, Lyon; before 1964 to 1971, Kofler collection (inv. 650 A); 1971–, Keir collection.

LITERATURE: L Palustre, 'L'Orfèvrerie religieuse', *Catalogue de la Collection Spitzer*, I, Paris, 1890, cat. 44; Rupin, 1890, 322; F. Spitzer sale, Rue de Villejust, Paris, 17 April – 16 June 1893, lot 252, pl. VI; Paris exhibition 1900, cat. 2503; Zürich exhibition 1964, cat. 847; Kofler collection catalogue E 41, pl. 15; Aachen exhibition 1965, cat. E 41, pl. 68; Gauthier 1967*b*, 152 n. 7 (5); *Corpus*, vol. II, Rel.III B 10, (ph. 1367, 6596, 16692–3).

NOTE: 1. Gauthier 1972, 112–14, cat. 64–5.

# 7 Crozier head (plate 7).

*Champlevé enamel on copper. H. 27.5cm. Limoges, shaft and knop about 1190, volute about 1220.*

Wood core, modern. Copper shaft, knop and volute, *champlevé*, enamelled, engraved, chased and gilded. Enamel: cobalt blue, azure blue; red, black, bright green, yellow; in single or mixed fields. Figures and decoration either reserved and engraved or enamelled in mixed colours with serrated borders to the fields. Areas of loss to gilding and enamel.

The shaft is cylindrical with a fretwork of lozenges, each chased with a running 'garland' of laurel leaves; in the lozenges, small dragons with flowering tails gilded on a blue ground alternate with cross-shaped flowers, whose single or double clusters of petals are enamelled (cobalt blue-azure blue-white and blue-green-yellow).

Flattened knop: on a deep blue ground, a foliage stem defines ultramarine blue fields and develops little multi-coloured flowers, around dragons with flowering tails who bend back their heads to bite a flower. Volute: collar of chased and gilded leaves; background enamelled blue to simulate the skin of a snake, narrowing at its end to become a dragon's head, whose eyes are encrusted with enamel; crocketing on the spine of the volute, which ends in a half-palmette with pistils; in the centre of the volute is a chased and gilded lily flower.

Although this beautiful crozier appears to be uniform, its parts are not all contemporary. The volute belongs to the second or third decade of the thirteenth century, the shaft and knop to the last decade of the twelfth century, cf. the shaft of the crozier in the Musée d'Inguimbert at Carpentras (Vaucluse),[1] where a typical twelfth-century volute, of prismatic section, is decorated with a big multi-coloured octopus-palmette. The gilded 'garland' pattern is already to be found perfectly executed on the two book-covers in Madrid (Instituto Valencia de Don Juan) and Paris (Musée de Cluny).[2]

P. C.

PROVENANCE: 1880–1900, Desmottes collection, Paris; before 1905, Boy collection, Paris; 1905, acquired by the dealer Dazzi, Paris; before 1921, Raoul Heilbronner collection, Paris; before 1931, Alfred Rütschi collection, Lucerne; until 1944, Cassel collection, Ruoms (Ardèche); 1944, confiscated during the German Occupation for inclusion in a proposed museum to the glory of the Führer at Linz, Austria; 1947, recognised at Munich 'collecting point' (B 1450) and returned to Baron Cassel; until 1954, Cassel collection; before 1964 to 1971, Kofler collection (inv. 653 A); 1971–, Keir collection.

LITERATURE: Reussens 1882, especially p. 23, fig. 13; Paris exhibition 1884, cat. 16; Desmottes sale, Hôtel Drouot, Paris, 19–23 March 1900, cat. 31, pl. 12; Boy sale, Galerie Georges Petit, Paris, 15–24 May 1905, cat. 153, fig. p. 29; R. Heilbronner sale, Galerie Georges Petit, Paris, 22–3 June 1921, cat. 41, pl. p. 14; von Falke 1928, 24; Rütschi sale, Lucerne 1931, lot 35, pl. XXI; Marquet de Vasselot 1941, no. 204; Cassel sale, Hôtel Drouot, Paris, 9 April 1956, cat. 24; anonymous sale (Madame X), Hôtel Drouot, Paris, 13–14 June 1956, pl. XXVIII; Zürich exhibition 1964, cat. 901, pl. 100 (Review: Lasko 1964, fig. 15); Kofler collection catalogue E 107, pl. 23; Aachen exhibition 1965, cat. E 107; Corpus, vol. I, H 5, 2 (ph. 6546–7, 10938, 15273) and II.

NOTES: 1. Corpus, vol. I, H 5, 1.
2. Corpus, vol. I, F 1, 2.

a deep blue ground, which is decorated with scrolled stems and multi-coloured flowers, alternately red-green-yellow and red-blue-white. Christ's head falls to his right, his arms held horizontally but with a slight bend at the elbows and thumbs extended. The abdomen twists to his right, the rib-cage is rendered by a series of lines around a dividing line down the centre of the stomach. The loincloth has a decorated belt and central fold; it is gently modelled over the legs by means of a series of lines which descend from the outside and rise from the centre, while there is a fall of material from his left hip. The foot-rest is enamelled green with red spots. Titulus: IHS/XPS, for *Ihesus Christus*, enamelled beneath the hand of God emerging from clouds. The marked elongation of the limbs forms a notable contrast to the tiny scale of the hands, feet and head. Decorative motifs are repeated, interrupted or form curvilinear patterns.

These stylistic features are without precise parallels in Limoges work, but no. 8 stands at the head of two different series among the earliest crosses with gold grounds. First, it anticipates the group with background stems and enamelled flowers, e.g. Metropolitan Museum, New York 17.190.758 and Musée de Cluny, Paris 22/757.[1] Secondly, it relates to the crosses with grounds studded with 'gems', such as Museos de Arte, Barcelona 65508 and National Gallery of Art, Washington 233–1 (Widener collection).[2] The high quality of the cutting of the head of Christ on no. 8 is comparable to certain heads of late twelfth-century date in Castille, e.g. the *châsse* in the Treasury of the Abbey of Santo Domingo de Silos, near Burgos.[3]

P. C.

PROVENANCE: before 1905, G. Chalandon collection, Lyon; 1960 to 1971, Kofler collection (inv. 662); 1971–, Keir collection.

LITERATURE: Migeon 1905, 28 (no. 42), fig. p. 18; Thoby 1953, no. 55, pl. XXVI; Gauthier 1954, 12; Cologne exhibition 1960, cat. 84, pl. 75; Zürich exhibition 1964, cat. 887, pl. 99 (Review: Demoriane 1964, 97 and col. pl.); Kofler collection catalogue E 93, pl. 21, Aachen exhibition 1965, cat. E 93 and col. pl. 47; Corpus, vol. I, H 4, 12 (ph. 1374, 6552).

NOTES: 1. Corpus, vol. I, H 4, 1 (New York); H 4, 2 (Musée de Cluny).
2. Corpus, vol. I, H 4, 9 (Barcelona); H 4, 10 (Washington).
3. Corpus, vol. I, H 3, 10 (Silos).

## 8 Central plaque of a cross (plate 8).

*Champlevé enamel on copper. H. 35.5cm; W. 24.4cm. Limoges, about 1190–95.*

Cross, with oval-shaped intersection (11.8cm × 12cm) and thirty pinholes. Single copper plate cut out, *champlevé*, enamelled, engraved and gilded. Enamel: cobalt blue, azure blue; red, turquoise, dark green, bright green, yellow, white; in single or mixed fields, up to a range of four colours. Figure reserved and chased, on a ground enamelled with decorative motifs within fields with punched borders. Head applied separately and of classical type. Some loss of enamel at the base of the shaft. Christ is shown dead on the cross, with cross-nimbus, and four nail-holes through hands and feet. Cross of turquoise enamel studded with 'gems', against

## 9 Book-cover, with Christ in Majesty (plate 9).

*Champlevé enamel on copper. H. 30.3cm; W. 19.2cm. Limoges, about 1195–1200.*

Copper plaque (H. 22.5cm; W. 11cm), with ten pinholes but no wooden backing, set into a bevelled frame decorated with rosettes in circles (a type of frame often imitated in the nineteenth century). Outer frame of engraved copper, with a foliage scroll and two angels, their heads separately applied. Central plaque, with the figures and some of the decoration engraved, reserved and gilded, the heads separately applied, the background and the rest of the decoration enamelled as

follows: cobalt blue, azure blue; red, black, green; turquoise; yellow; white; in single and mixed fields, e.g. red-yellow-dark blue, or red-dark blue-azure blue-white. Christ with blue and white 'cloud' nimbus, its cross green, is seated on the rainbow, his feet resting on a five-sided footstool. With his right hand he blesses, with his left he supports a closed book on his knee. 'Cloud' mandorla divided from the brilliant blue central area by a turquoise band. In the ultramarine blue spandrels, the Evangelist symbols with red and white books or a white scroll. At the top, Matthew (winged man) and John (eagle) face inwards towards Christ; at the bottom, the two symbols (lion of Mark, calf of Luke) are addorsed, their heads turned back towards Christ.

There are some 200 book-covers included in the Corpus.[1] Stylistically, however, this plaque belongs to a group of fifteen pieces, of which nine are representations of Christ in Majesty, such as a book-cover in the British Museum (MLA 1913, 12–20, 4).[2] Among the chief characteristics of the group are (a) the decorative combination of enamelled discs with engraved stars, (b) the 'cloud' mandorla framing a plain enamelled band, and (c) the polychrome sections of an arc, which support the two Evangelist symbols at the top of the plaque.

<div align="right">P. C.</div>

PROVENANCE: before 16 May 1958, Lord Vernon collection, Wolverhampton; 1958 to 1971 Kofler collection (inv. 650A II); 1971–, Keir collection.

LITERATURE: Lord Vernon sale, Sotheby's, London, 16 May 1958, lot 48; Zürich exhibition 1964, cat. 846, pl. 92; Kofler collection catalogue E 40, pl. 14; Aachen exhibition 1965, cat. E 40, pl. 67; Gauthier 1967b, 152, n. 7(5) and 155, n. 11; Corpus, vol. II (ph. 3712, 6597–98, 16694, 16699).

NOTES: 1. Gauthier 1968; Corpus, vol. III, A 6.
2. Gauthier 1967b, fig. 64.

# 10 Gable-shaped plaque: two martyr saints (plate 10).

*Champlevé enamel on copper. H. 24.4cm; W. 18.2cm. Limoges, about 1200–1210.*

The plaque probably from the same *châsse* as:

(b) gable-shaped plaque with two martyr saints (Fitzwilliam Museum, Cambridge, McClean Bequest M31–1904). H. 24cm; W. 17.7cm

(c) rectangular plaque, with the Dormition of the Virgin (Paris, Louvre, OA, Orf. 72). H. 26cm; W. 20cm

Perhaps from a single large *châsse*, or a pair of *châsses*, containing relics of the Four Crowned Martyrs (*Quattuor Coronati*). The three plaques are contemporary and by the same enameller. No. 10 and (b), with ten pinholes, are either from the gable-ends or from the 'Transept' of a *châsse*: cf. the *châsses* in the Cathedral Treasuries of Pisa and of Agrigento.[1] Plaque (c), with ten pinholes, is from one of the sides of a *châsse*.

Copper sheets, *champlevé*, chased, engraved, enam-

elled and gilded. Enamel: midnight blue, deep cobalt blue, ultramarine blue; deep green, green, bright turquoise, red; yellow; white; in single fields, or set off with an edging colour, or fired in mixed fields: red-midnight blue-blue-white, red-midnight blue-green-yellow. No. 10 and (b) each have two seated crowned martyr saints holding palms and turned towards each other; below, two sarcophagi with strigil decoration open to show the bones of a body (skull, ribs, etc.). Inscriptions: (no. 10) CUSTODIT D(omi)N(u)S OMNIA OSSA S(an)C(t)OR(um); (b) EXULTABUNT D(omi)NO OSSA HUMILIATA. These texts (cf. Psalm XXXIII, 21; L, 10) do not allow a specific identification of the Four Crowned Saints, whose traditional attributes are masons' tools. In France their cult is rare but, significantly, some of their relics were preserved in the Treasury of St Sernin at Toulouse.[2]

Plaque (c) shows the Virgin lying on a draped couch, her hands crossed on her breast; twelve Apostles; two half-length angels with censers descending from the sky. Above, the inscription: REGINA MUNDI DE TERRIS ET DE, formerly continued on the neighbouring plaque, which perhaps showed the Virgin glorified in heaven or carried as a soul in Christ's arms, according to the Byzantine iconographic tradition. The hypothesis that (c) is associated with the two gable-shaped plaques is based on, first, the negative evidence that research on the Corpus of Limoges has failed to identify a single other piece of this stylistic group, and, secondly, that the three plaques are of the highest quality and definitely related closely to each other both in style and technique.

PROVENANCE: *No. 10*: 1847, Abbé Julien Gréau collection, Lyon; before 1901, Mark Antokolsky collection (Polish sculptor, of the Académie des Beaux-Arts de France in St Petersburg); before 1905, Boy collection, Paris; before 1908, Octave Homberg collection, Paris; before 1960 to 1971, Kofler collection (inv. 650T); 1971–, Keir collection.
*Plaque (b)*: before 1847 to 1850, Debruge-Duménil collection, Paris; 1857, exhibited in Manchester; before 1890, Lord Hastings collection; since 1904, Fitzwilliam Museum, Cambridge.
*Plaque (c)*: until 1828, Révoil collection; 1828, acquired by the Louvre from the Révoil collection.

LITERATURE: *No. 10*: Martin 1847–9, 247 and col. pl. XLIV; Antokolsky sale, Hôtel Drouot, Paris, 10–12 June 1901, lot 32; Boy sale, Galerie Georges Petit, Paris, 15–24 May 1905, lot 166; Homberg sale, Galerie Georges Petit, Paris, 11–16 May 1908, lot 515; Gauthier 1950, 49; Cologne exhibition, cat. 95; Zürich exhibition 1964, cat. 845, pl. 91 (Reviews: Demoriane 1964, 96; Kauffmann 1964, 21, fig. 14; Lasko 1964, 467 and colour pl.); Kofler collection catalogue E 39, pl. 13; Aachen exhibition, cat. 125b, pl. 370; Corpus, vol. II (ph. 6530, 6531, 8668, 8693, 8694).
*Plaque (b)*: Labarte 1847, cat. 681; Rupin 1890, 429, fig. 481; Dalton 1911, 101, no. 52; Gauthier 1972, 370, cat. 125a; Corpus, vol. II (ph. 550, 8691, 8708).
*Plaque (c)*: de Laborde 1852, 56–9, no. 41; Darcel 1883, 30–37, no. 64, D. 82; Rupin 1890, 149, fig. 224; Gauthier 1950, 49, 63 and 74, colour pl. 40; Vatican exhibition 1963, cat. 86; Gauthier 1972, 179–80 and 370, fig. 125, cat. 125c; Corpus, vol. II (ph. 18374–5, 18404–5).

NOTES: 1. Gauthier 1972, 335, 336, cat. 60 and 61.
2. L. Réau, *Iconographie de l'Art Chrétien*, III, *Iconographie des Saints*, Paris, 1958, 348–50.

## 11 Châsse, with angels and saints (figure 1).

*Champlevé enamel on copper. H. 11.8cm; W. 9.2cm; D. 6.4cm. Limoges, about 1195–1200.*

Casket, with pitched roof and gabled ends, on four cubical feet. The cresting is lacking. Originally eight copper plaques were pinned on a wooden core, two now lacking (roof and door of back). Copper plates *champlevé*, chased, enamelled, engraved and gilded. Enamel: three blues; two greens, red, black, turquoise; yellow; white, in single fields or mixed, with green or blue dominant and accents of red or black. Reserved figures chased and engraved, heads applied and of classical type (all plaques). Enamelled grounds studded with enamelled motifs, the borders of their fields decorated with zigzags or punched, a zigzag on the narrow framing borders.

On the front, roof and below: each has two roundels linked by discs, which encircle a half-length angel emerging from clouds, turned towards his neighbour, holding a book and making a gesture of witness. On each gable-end, a standing saint against a ground divided by three horizontal turquoise bands and decorated with stems ending in triangular leaves. The door in the back probably originally decorated with a diaper similar to that of no. 5. Although small, no. 11 with its series of angels is a rare piece, belonging to a group which is related to the eucharistic casket from the Abbey of Grandmont (Haute-Vienne), which was stolen from the Musée Municipal de Limoges on 1 January 1981.[1]

PROVENANCE: before 1964 to 1971, Kofler collection (inv. 670 L); 1971–, Keir collection.

LITERATURE: Zürich exhibition 1964, cat. 836; Kofler collection catalogue E 11, pl. 33; Aachen exhibition 1965, cat. E 11; *Corpus*, vol. II (ph. 4567–9).

NOTE: 1. M. -M. Gauthier, 'Emaux et orfèvreries', *Limousin Roman*, (Ed. Zodiaque) La Pierre-qui-Vire 1960, 287–8, fig. 8; M. -M. Gauthier, Notes and documents, dossiers: 'Châsse de saint Pierre d'Apt, Coffret eucharistique de Grandmont', *L'Information d'Histoire de l'Art*, no. 2, 1964, 78–83, with fig.

## 12 Châsse, with the condemnation and martyrdom of St Stephen (plate 11).

*Champlevé enamel on copper. H. 16.3cm; W. 12.3cm; D. 6.1cm. Limoges, about 1200–1210.*

Casket with pitched roof and gabled ends, on four cubical feet. Door in the back. Wooden core, its bottom still covered with original layer of minium and *gesso*. Eight copper plaques, with regularly spaced pins. Cresting, with two groups of four pierced horse-shoe arches, enamelled boss and three crowning projections topped by balls. Copper plates *champlevé*, engraved, enamelled and gilded. Enamel: deep blue, azure blue; red, blue-black, green; turquoise; yellow; white, in single fields or mixed in blue or green tones, with black and red

accents. Figures reserved and engraved, their heads applied separately and of classical type (on the front only). On the front and ends, the enamelled grounds are studded with enamelled or reserved motifs, the edges of their fields punched. On the back, the geometric decoration is reserved and enamelled. On the front (roof), Stephen condemned before the Jewish Sanhedrin, with its president (?) crowned and seated to the left, the saint pushed by one of his executioners whilst another precedes him to the right, the stones held in a fold of his tunic; below, Stephen stoned by two executioners. He is kneeling with his arms outstretched to heaven, but the hand of God which is normally shown above him has been omitted. The backgrounds are studded with little discs and multi-coloured rosettes. On the gable-ends, a standing saint holding a book, against a blue ground divided by two horizontal turquoise bands. On the back, a diaper of deep blue grounds filled with small gilded crosses; borders of two colours, with little crosses or dashes.

The martyrdom of St Stephen was a favourite scene with the Limoges enamellers of the first quarter of the thirteenth century. The prototypes of the series, the *châsse* of Malval in the Musée Municipal de Guéret (Creuse; cat. musée 7) and the *châsse* of Gimel (Corrèze), have *vermiculé* grounds.[1] There are two groups of scenes represented, either, as here, the condemnation and the martyrdom (*châsses*: Musée Municipal de Limoges, 303 – stolen 1 January 1981; Museos de Arte, Barcelona, 65526; Museum of Art, Princeton University, 4391)[2], or the martyrdom and the soul of the saint being carried up to heaven (Malval *châsse*).

PROVENANCE: until 1944, Cassel collection, Ruoms, Ardèche, France; confiscated by the German occupation authorities for a proposed museum to the glory of the Führer at Linz, Austria; January 1947, recognised at the 'collecting point', Munich (B 1448) and returned to Baron Cassel; after 1954, the Paris dealer, Brimo La Roussilhe; before 1964 to 1971, Kofler collection (inv. 670 M); 1971 –, Keir collection.

LITERATURE: Cassel sale, Hôtel Drouot, Paris, 9 April 1954, lot 19, pl. II; Zürich exhibition 1964, cat. 827; Kofler collection catalogue E 2, pl. 2, 26; Aachen exhibition 1965, cat. E 2, pl. 55; *Corpus*, vol. II (ph. 1664, 4563–6, 6522, 10925).

NOTES: 1. *Corpus*, vol. I, G 1, 2 (Malval) and vol. I, D 3, 1 (Gimel); Gauthier 1950, pls. 9, 10.
2. W. F. Stohlman, 'A Limoges reliquary', *Records of the Museum of Historic Art, Princeton University*, III, 1 Spring 1944, 5; M. -M. Gauthier, *Guide du Musée Municipal de Limoges: Collection Egyptienne, Emaux*. Limoges, 4th edition 1977, 49 (inv. 303); Gauthier 1972, 339, cat. 69 with fig.

## 13 Châsse, with the Judgement of Solomon (?) (plate 12).

*Champlevé enamel on copper. H. 16cm; W. 11.8cm; D. 5.8cm. Limoges, about 1200–1210.*

Casket, with pitched roof and gabled ends, on four cubical feet. Door in the back. Wooden core covered with eight copper plaques attached by pins. Cresting, with pierced rectangular openings topped by circles, two

ball-shaped projections at the ends. Copper plates *champlevé*, engraved, enamelled and gilded. Enamel: dark blue, azure blue; red, green, black, turquoise; yellow; white, in single fields, or mixed, with three colours in a range of blue or green. On the front, the figures are reserved and engraved, with applied heads; on the gable-ends, the figures are engraved; the grounds are enamelled and studded with enamelled and reserved motifs, the borders of their fields punched. On the back, the geometric decoration is reserved and enamelled. On the front, below, probably the Judgement of Solomon (I Kings III, 16–28), but in abridged and unusual form: on the left, an enthroned king crowned and holding a sceptre, then a soldier with a sword and at his feet a cradle with a baby entirely swathed; finally, two women with robes falling to their feet, making gestures of despair.

Such a scene would be unusual, and indeed on a Limoges piece, unique; nor do the three three-quarter length saints on the roof of the *châsse* help with its identification. It is however possible that the *châsse* was made for biblical relics, e.g. of Solomon or the two children, for the study of inventories shows that there were Hebrew relics inspired by the Bible stories circulating in Europe in the thirteenth century[1]. On the other hand, the scene could be a reduced version of a much commoner subject, the Massacre of the Innocents, for it is not certain whether the child in the cradle is alive or dead: swathed as it is, it could be symbolic of death and resurrection, by analogy with the Infant Jesus in the manger at Bethlehem or Lazarus swathed and rising from his tomb. On the gable-ends, a standing saint, against a blue ground divided by a horizontal turquoise band and decorated with pairs of multi-coloured rosettes. On the back, a diaper of discs enclosing quadrilobes, arranged regularly in rows, with little gilded crosses between. Borders, with little crosses of midnight blue and red. The plaque to the left of the door drawn or mounted in reverse when the *châsse* was made (border of little crosses and 'cloud' motif reversed).

No. 13 belongs to a phase of Limoges production which saw the appearance of numerous *châsses* decorated with the lives of the saints. Approximately one hundred survive, dedicated to, among others, St Thomas Becket,[2] St Stephen (e.g. a *châsse* in the Musée Municipal de Limoges (stolen 1 January 1981)[3] or another in the Museum of Art, Princeton University) and St Valerie.[4]

PROVENANCE: before 1910, Cottreau collection, Paris; before 1964 to 1971, Kofler collection (inv. 670 N); 1971–, Keir collection.

LITERATURE: Cottreau sale, Galerie Georges Petit, Paris, 28–9 April 1910, lot 43; M. Hamel, 'La Collection Cottreau', *Les Arts*, 1910, fig. p. 7; Zürich exhibition 1964, cat. 828; Kofler collection catalogue E 3, pls. 3 and 27; Aachen exhibition 1965, cat. E 3, pl. 56; *Corpus*, vol. II (ph. 4576–9, 6527).

NOTES: 1. Correspondence and conversations with E. Panofsky (letter to M. -M. Gauthier, 12 May 1964) and with Gerhard Schmidt at the Index of Christian Art, Princeton University. See also M. -M. Gauthier, *Les Routes de la Foi*, Fribourg (in preparation).
2. S. Caudron, 'Thomas Becket', *Actes du colloque International de Sédières*, 11–24 August 1973, 233–41.
3. M. -M. Gauthier, *Guide du Musée Municipal de Limoges: Collection Egyptienne, Emaux*. Limoges, 4th edition 1977, 49 (inv. 303).
4. Gauthier 1955.

## 14  Châsse, with Christ in Majesty (figure 1).

*Champlevé enamel on copper. H. 18cm; W. 11cm; D. 6.8cm. Limoges, about 1185–95.*

Casket, with pitched roof and gabled ends, on four square feet. Cresting, pierced by ten rectangular openings below circular holes, originally with three crowning balls, one now lost, the central one surmounted by a cross. Originally eight copper plaques on an oak core; the back has three plaques and a door, the two roof plaques now lacking. Enamel: four blues; vivid green, red, black, light turquoise; yellow; white, in single fields or mixed up to a range of four tones, with a dominant blue or green and accents of primarily red. Figures reserved, chased and engraved, with heads applied and of classical type (on the front only). Blue grounds, studded with enamelled, gilded and punched motifs. On the front, below, in three rectangular fields with 'cloud' borders: centre, Christ in Majesty enthroned on a rainbow, blessing, with a book on his left knee, his mandorla with four engraved star-like discs in the spandrels; flanked by two fields each with a standing Apostle holding a book, the ground divided horizontally by a turquoise band. On each gabled end, a similar standing figure beneath an arch capped by a small turret. On the back, the door has a diaper of multicoloured quatrefoils in green and blue squares within turquoise borders; the side plaques with 'cloud' motif; the borders decorated with little crosses.

The figures are tightly structured and static, gesture is contained within the silhouettes. The drapery folds are evenly distributed and the figures set on fields of a single deep blue. These features suggest that no. 14 belongs to approximately the same period of development as the latest *châsses* with gilded *vermiculé* backgrounds.

P. C.

PROVENANCE: Abbé Joyaux, Oradour-sur-Glane (Haute-Vienne); before 1951, Henri Leman collection, Paris; before 1964 to 1971, Kofler collection (inv. 670 A); 1971–, Keir collection.

LITERATURE: Henri Leman sale, Hôtel Drouot, Paris, 8 June 1951, lot 111; Zürich exhibition 1964, cat. 835, Kofler collection catalogue E 10, pl. 33; Aachen exhibition 1965, cat. E 10.

## 15  Gable-shaped plaque from a châsse: an Apostle (plate 13).

*Champlevé enamel on copper. H. 42.8cm; W. 11.7cm. Limoges, shortly after 1200.*

Five-sided plaque, with ten pinholes, cut out at base to form two rectangular feet. Copper *champlevé*, engraved, enamelled and gilded. Enamel: dark blue, clear blue, red, green, black, purple; turquoise; yellow; white; in single and mixed fields. Head of figure separately applied, of a marked classical character. The figure and decorative elements are reserved; the enamelled ground with reserved and punched fields. The Apostle is nimbed, barefoot and dressed in a robe with

an orphrey band at the neck, a mantle falling from his left shoulder. His right hand is open against his breast, his left hand holds a closed book. The deep blue ground is formed by a trefoil-headed arch, topped by five little turrets, their gilding standing out against the purple enamel of the spandrels which are mottled with spots of turquoise. The reserved gilded figure is set among foliage scrolls: two stems spring from the bases of the framing colonnettes and climb upwards, their flowers of different forms and alternating: palmettes, triangular shaped blooms, etc., with a varying and subtle range of colour combinations, employing mainly blue and green; stems and flowers have delicate punched patterns. The border is of semicircular 'clouds' of four colours, framed by a dark blue.

A rich foliage decoration can be found on a certain number of objects, dating from the last quarter of the twelfth century, for instance on the remarkable *châsse* in the Treasury of the Cathedral of Apt,[1] but the foliage of no. 15 with its large flowers has no precise parallels; the plaque may date from a somewhat later period than the main group.

PROVENANCE: before 1960 to 1971, Kofler collection (inv. 650T 1); 1971–, Keir collection.

LITERATURE: Cologne exhibition 1960, cat. 96; Zürich exhibition 1964, cat. 849, pl. 94; Kofler collection catalogue E 43, pl. 17; Aachen exhibition 1965, cat. E 43; *Corpus*, vol. II (ph. 6534–5).

NOTE: 1. *Corpus*, vol. I, F3, 1.

# 16   Five-sided plaque: Crucifixion (plate 14).

*Champlevé enamel on copper. H. 24.2cm; W. 16.7cm. Limoges, about 1200–1205.*

Five-sided plaque, with eight pinholes. Heavily cut down on both sides, with considerable loss of enamel, then restored, the damaged enamel replaced with mastic and reused before 1882 as the central panel of a triptych.[1] Copper plate *champlevé*, engraved, enamelled and gilded. Enamel: cobalt, ultramarine and azure blue; red, green, bright turquoise; yellow; white, in single fields, sometimes mottled, and in mixed fields up to a range of three tones, with alternately blue or green predominating, and red accents. Figures reserved and engraved, with heads separately applied, of classical type and very large (11–15mm). Grounds enamelled and decorated with multi-coloured motifs with zigzag edges, the borders of their fields punched. Christ nimbed, with four nail-holes, the cross blue with gilded dots and green edging; Christ's head is gently inclined towards his right shoulder, his arms slightly bent at the elbow; there is schematic line engraving on the breast, stomach and rib-cage; Christ's body is twisted to his right, the loincloth knotted on his left hip and the fall of drapery on his left side. Azure blue foot-rest, mottled with red. Titulus reversed: XPS/IHS, for *Christus Ihesus*. Below, Adam rises from his tomb, his two hands outstretched towards Christ. Flanking the cross, the Virgin, her hands crossed in front of her, and St John

holding a book; both are standing frontally on multi-coloured hillocks. Two angels emerge from clouds on either side of Christ's head. Above, in a triangular field, Christ with cruciform nimbus emerges from clouds, blessing with his right hand and presenting an open book in his left hand.

For the double-scrolled, interlacing stems, and the alternating colours of the palmette leaves with their zigzag edges, cf. the earlier *châsse* in the Treasury of the Cathedral of St Vitus, Prague.[1] No. 16 probably comes from a tabernacle or from a *châsse* 'transept'.

P. C.

PROVENANCE: before 1882, Johannes Paul collection, Hamburg; before 1960 to 1971, Kofler collection (inv. 650 A I); 1971–, Keir collection.

LITERATURE: Johannes Paul sale, Cologne, 16 October 1882, lot 603 (old photograph in the photographic records of the Département des Objets d'Art, Louvre); Rupin 1890, 501, fig. 555; Cologne exhibition 1960, cat. 95, pl. 71; Zürich exhibition 1964, cat. 848; Kofler collection catalogue E 42, pl. 16; Aachen exhibition 1965, cat. E 42, pl. 69; *Corpus*, vol. II (ph. 6532–3, previous montage, pl. 5018).

NOTE: 1. Gauthier 1973, 106, 333, cat. 55.

# 17   Châsse, with angels and saints (plates 15–16, figure 2).

*Champlevé enamel on copper. H. 27.1cm; W. 24cm; D. 11.5cm. Limoges, about 1205–15.*

Casket, with pitched roof and gabled ends, on rectangular feet (corner foot of left end lacking). Cresting, with a row of pierced horseshoe arches; one of the three crowning projections is complete. Round-headed door in right gable-end, with keyhole and large hinge (added), originally attached with seven pinholes. Without wooden core; the eight copper plaques are jointed with mortise and tenon. On the front, two horizontal copper strips fixed by rivets cover the joins at top and bottom of the casket. On the roof (front), a rectangular plaque, set with a large oval crystal, is a later insertion, when the reliquary was transformed into a monstrance. On the back, the roof and casket plaques are riveted together from inside. Copper plates *champlevé*, enamelled, engraved, chased and gilded. Enamel: three blues; green, red, turquoise, yellow; white, in single or mixed fields up to three or four colours, dominated by blue or green but with red accents. On the front, applied figures enamelled, chased and gilded on engraved reserved grounds. On the back and ends, figures reserved, engraved, enamelled and gilded on enamelled grounds, decorated with reserved and enamelled motifs.

On the front, each plaque has four three-quarter length saints (two lost from the roof, their haloes cut by the inserted plaque): azure blue mantles over cobalt blue tunics edged with green, right hands in a gesture of witness, left hands holding a red book; the grounds *vermiculé*, studded with glass-set discs, the roof with cross-motifs within the *vermiculé* scrolls. The decoration on the inserted plaque has a classical flavour. On the back, casket and roof with three circular fields,

alternately ultramarine blue and turquoise, joined by discs, with a foliage scroll and palmettes beneath, half-length angel in each field: they emerge from clouds, their long pointed wings intersecting between the frames of the circular fields; on the roof, two make a gesture of witness, the third holds an instrument like a hammer (?); on the casket, the central angel is bearded.

This *châsse* is one of the earliest decorated with circular fields of blue, studded with little discs and multi-coloured rosettes, a scheme which was to become in a simplified form extremely popular in the second half of the thirteenth century on the *châsses* with opening roof.[1] On the right end is a standing figure of a saint, unbearded, with book and sceptre (or key?); on the left end, a three-quarter length angel as on the back, ground with multi-coloured discs. This workshop is characterised by gentle, yet supple draperies which lend a substance to the forms, by the balance held between the gilded and the blue areas, by the flame-like silhouettes of the angels and the flowers, by the contrasting decorative schemes employed on the two ends and by the sheer inventiveness displayed in the selection of the ornamental motifs. Here there are elements of both the archaic and the new; an original artist innovator must have been working alongside more traditionally based craftsmen.

PROVENANCE: before 1960 to 1971, Kofler collection (inv. 670 J); 1971–, Keir collection.

LITERATURE: Cologne exhibition 1960, cat. 91, pl. 77; Zürich exhibition 1964, cat. 830, pls. 84–5 (Review: Kauffmann 1964, 15 with fig); Kofler collection catalogue E 5, pls. 6, 7 and 29; Aachen exhibition 1965, cat. E 5, pls. 59–60; Gauthier 1966b, 23, figs. 5–6; Gauthier 1966a, 951, C 33; M. -M. Gauthier, 'Reliques des Saints Innocents et châsse limousine au trésor de Saint Denis', *Gesta*, XV, 1 and 2, (International Center of Medieval Art) 1976, 297, figs. 6–7; *Corpus*, vol. II (ph. 4574–5, 5887–8, 6523–4, 16695–7).

NOTE: 1. *Corpus*, vols. IV and V.

# 18  Applied figure: St John (figure 2).

*Champlevé enamel on copper. H. 6.1 cm; W. 2.2 cm. Limoges, about 1200.*

Two pinholes for attachment. A curved tongue of copper, *champlevé*, engraved, enamelled and gilded. Enamel: medium blue, black, red, turquoise, white; in single fields. Half-length figure, the body in low relief, the head flat and turned to his right, the features in white enamel within a gilded and chequered halo, with turquoise band. Hair black, eyes black, lips red, mantle blue and falling from left shoulder, right hand open on his breast, left hand holding a book. The pose, gesture and position of the figure (see the oblique angle of the cut base) suggest that this is St John, witnessing the Crucifixion, probably from the right arm of the front face of a cross. A large number of the Limoges crosses, which were exported to Scandinavia c.1200, were decorated with similar applied figures, e.g. Lund Museum (28447 a, b).[1] Cf. also Walters Art Gallery, Baltimore (44.258).[2]

PROVENANCE: before 1964 to 1971, Kofler collection (inv. 651, E11); 1971–, Keir collection.

LITERATURE: Zürich exhibition 1964, cat. 866; Kofler collection catalogue E 62, pl. 41; Aachen exhibition 1965, cat. E 62; *Corpus*, vol. II (ph. 4587).

NOTES: 1. B. -M. Andersson, 'Emaux limousins en Suède. Les châsses, les croix', *Antikvarisk Arkiv*, 69, Kunglie Vitterhets Historie och Antikvitets Akademien, Stockholm, 1980, 1–91, figs. 38, 39. 2. *Corpus*, vol. II.

# 19  Virgin and Child enthroned (plate 17, figure 2).

*Embossed and repoussé copper; champlevé enamel. H. 30 cm; W. 14 cm. Limoges, about 1225–35.*

Statuette of the Mother of God, probably intended as a receptacle for the pyx with the reserved Host. Solid copper, without a wooden core. Both figures of two shells of metal, fitted together down the sides and pinned horizontally. The Child slotted into his mother's knee, the Virgin into the throne. The two crowns were made separately and also hold the shells of metal together. Rectangular chamfered plinth lacking its four feet, carries a row of round-headed studs. Throne with pierced arches along the top and four corner posts (5 or 8 mm thick), which are higher at the back (18 cm) than the front (14.8 cm). The door and one of the hinges are lost from the rectangular opening in the back of the throne. The copper sheets were cut out and embossed, then *repoussé* in low relief, finally chased, engraved and gilded. The hands and feet were hammered out of the solid copper. The plinth was bevelled, engraved, then enamelled and gilded. Enamel: medium blue, pale blue; red, dull green, pale turquoise; yellow, white; some mixed fields of two or three tones of blue or green.

The Virgin is seated frontally, with the Child on her left knee. A veil covers her head, except where elegant strands of hair frame her forehead. The crown is a double circlet, the inner topped with fleurons (originally eleven in number), the outer with settings for stones (originally seven big gems alternated with eight pairs of cabochons). As for her garments, the lower parts of the alb are arranged in delicate folds, the dalmatic is diapered with a lozenge pattern enclosing discs, a jewelled orphrey was originally attached to the hem, whilst the open mantle around the shoulders has braiding at the neck. In her right hand there must have been a sceptre, which slotted into the hole in her knee and passed through the circle formed by the thumb and two fingers of her right hand. The Child is also seated frontally, with a closed book resting on his left knee, while he blesses with his right hand. His tunic is studded at the neck, his overmantle arranged like a toga, his crown studded and surmounted by a cross. The youthful character of the mother and child is conveyed by plump, well-rounded faces, in which the eyes are picked out in enamel.

The softly modelled folds of the alb, tunic and mantle are typical of the Limoges style, which makes its first appearance in about 1220–25.[1] Formal patterns on the dalmatic are set off against this soft modelling of the draperies, a contrast found in several other similar Majesty groups.[2] Most unusually, an old tradition has

come down to us about the Arlanza Majesty. In Castille she was known from the fourteenth century onwards as the *Virgen de las Batallas*, the 'Virgin of Battles'. In other words she was a Virgin *nikopoieta* (of Victory), her function similar to that of the icon of the Virgin, which the Byzantine Emperor carried in defence of Constantinople. Nevertheless, her original liturgical function is clear: she was made to receive a container for the reserved Host.[3]

PROVENANCE: According to legend, belonged to Count Ferdinand Gonzales de Castille (tenth century); until 1836, in the abbey of San Pedro de Arlanza, near Burgos; 1836–78, Burgos episcopal palace and in the possession of Don Eusebio Campuzano, dean of Seville; 1878, Antoine d'Orléans, duke of Montpensier, fifth son of Louis-Philippe (d.1890, near Seville) and subsequently his son Antoine de Bourbon, duke of Galliera, Infante of Spain, then the Parisian dealer Desmottes and baroness A. de Kerchove, New York; prior to 1949, acquired for Joseph Brummer collection, New York; 1951, the dealer Paula de Königsberg, Buenos Aires; 1955, anonymous collection, New York; before 1960 to 1971, Kofler collection (inv. 651); 1971–, Keir collection.

LITERATURE: C. Rohault de Fleury 1878, 350, pl. CXXXIV; Joseph Brummer sale, Parke Bernet Galleries, New York, 23 April 1949, lot 724; Buenos Aires exhibition 1951, cat. 59; Hildburgh 1955, 130–31, pl. LI; Cologne exhibition 1960, cat. 92, pl. 73; Zürich exhibition 1964, cat. 826, pl. 83 (Reviews: Demoriane, 1964, 95 and colour pl.; Lasko, 1964, fig. 12); Kofler collection catalogue E 1, pls. 1 and 25; Aachen exhibition 1965, cat. E 1, pl. 54; Gauthier 1966b, 30; Gauthier 1970, 90, no. 2; *Corpus*, vol. III (ph. 5016–7, 6600–03, 10712–4).

NOTES: 1. Gauthier 1972, 183–7, cat. 129–31.
2. Hildburgh 1955, 131, pl. LII (Victoria and Albert Museum, London, Zouche collection), 128, pl. XLIX (Palencia), 127–8, pl. XLVIII (Artajona), 129 (Zürich, Rütschi collection 1926); Musées royaux d'art et d'histoire, Brussels, inv. 427.
3. Gauthier 1981.

# 20   Gable-shaped plaque: St Cucuphas (plate 18).

*Champlevé enamel on copper. H. 22.5cm; W. 14.2cm. Limoges, about 1210–15.*

Five-sided plaque, probably from the gable-end or 'transept' of a large *châsse*, with ten pinholes, *champlevé*, engraved, enamelled and gilded. Enamel: lapis blue, medium blue; green, red, turquoise; yellow; white; in single or mixed fields, up to a range of four colours. Reserved figure, with applied head; enamelled ground, with reserved and enamelled motifs. Inscription: + SANTI: QOQOFARDI MARTIR. St Cucuphas is nimbed and shown *orans*, emerging from a turquoise arc decorated with a 'cloud' band, within a reserved mandorla. Clothed in a dalmatic, he is carried up to heaven by four hands which grasp the mandorla (the hands of two angels, originally shown complete on the neighbouring plaques?). The identification of the saint, Cucuphas, *Cocofardus*, is important: born in Africa, martyred in Barcelona under Diocletian in 304 AD, his cult was firmly established in Catalonia, where an abbey, San Cugat del Vallès, was founded on the traditional site of his tomb, according to legend after 312.[1]

The iconography of the soul being carried up to heaven was a favourite with Limoges enamellers; similar scenes are found on *châsses* made for relics of St Valerie,

St Stephen or St Thomas Becket.[2] The head of St Cucuphas was preserved as a relic at St Denis from at least the Carolingian period onwards.[3] The deep blue ground is decorated with spiralling foliage stems, their branches veined and forming double scrolls or interlacing. The big flowers, enamelled in a range of colours and gilded, almost resemble lilies. A 'cloud' motif is enamelled on the upper and lower border. No. 20 must represent an important surviving fragment of a big house-shrine, cf. in form, style and technique the *châsses* in the Cathedral treasuries of Agrigento and of Pisa.[4]

PROVENANCE: Before 1910, Charles Mannheim collection, Paris; before 1931, Rütschi collection, Zürich; 1937, Fischer (dealer), Lucerne; before 1957 to 1971, Kofler collection (inv. 650); 1971–, Keir collection.

LITERATURE: *The Collection of the late Mr Charles Mannheim, Paris* (Georges Petit, printers) 1910, cat. 70, ill.; von Falke 1928, cat. 13, pl. 7; Rütschi sale, Lucerne, 5 September 1931, pl. VIII (catalogue by O. von Falke); Gauthier 1957, 165, fig. 21; Barcelona exhibition 1961, cat. 434; Zürich exhibition 1964, cat. 844, pl. 90 (Review: Lasko 1964, fig. 11); Kofler collection catalogue E 38, pl. 12; Aachen exhibition 1965, cat. E 38, pl. 65; Gauthier 1976; *Corpus*, vol. II, 2 (ph. 1373, 6528, 12988).

NOTES: 1. J. Mas, *Les Reliquies del Monastir de Sant Cugat del Vallès*, Barcelona, 1908.
2. Gauthier 1955, 35–80.
3. Montesquiou-Fezensac, D. Gaborit-Chopin, *Le trésor de Saint-Denis, Inventaire de 1634*, Paris, 1977, no. 273.
4. Gauthier 1972, cat. 60–61.

# 21   Statuette: a young man holding a scroll (figure 3).

*Repoussé copper and champlevé enamel.*
*Figure H. 16.5/16.6cm; W. 8cm. Limoges, about 1220–25; plinth post-medieval, in the classical style.*

Apart from about fifty Majesty groups with the Virgin and Child (cf. no. 19), Limoges figures 'in the round' are extremely rare. Only the Angel-reliquary of St-Sulpice-les-Feuilles, much earlier in date, can be compared with no. 21 in technique, subject-matter and scale,[1] but in both cases their original function as part of a larger ensemble is unknown. Constructed from three double shells of copper, fitted together down the sides and fixed with cross-pins (the pin heads have been mistaken for the positions where wings were broken off)[2]. The hands and feet were cast and worked from the solid copper. The scroll was separately made, *champlevé* and enamelled; head, body and draperies *repoussé*, then engraved and gilded. Dark blue enamel for ground of reserved, gilded inscription and for eyes. The young man is standing frontally, his head slightly tilted towards his right shoulder, his hair cut short and 'domed'. He wears an alb with decorated neck-band and a toga-like mantle, which falls from his left shoulder. He holds the scroll opened diagonally across his body. The inscription, in capitals with some uncial forms, reads (interrupted by the left hand): Q VEROBONAR(um?) AR- -LEGO. This text has not been identified (one of the Minor Prophets?).

The rounded features, the balanced harmony of pose and gesture, as well as the life that the artist has

breathed into the generously articulated limbs, can be stylistically paralleled in the applied figures, which are themselves almost 'in the round', on the tabernacles in the Cathedral treasury of Chartres and from Cherves (Charente), now in the Metropolitan Museum, New York.[3] These two ensembles seem to be slightly earlier in date than the deacon figure at Les Billanges (Haute-Vienne) and the celebrated Apostles, which come from the Matutinal and High Altars of the Abbey of Grandmont (Haute-Vienne), of c.1225–30.[4]

PROVENANCE: before 1908, Octave Homberg collection, Paris; before 1964 to 1971, Kofler collection (inv. 651 F); 1971–, Keir collection.

LITERATURE: Migeon 1904, 37; O. Homberg sale, Galerie Georges Petit, Paris, 11–16 May 1908, lot 529 and pl.; Zürich exhibition 1964, cat. 899; Kofler collection catalogue E 105, pl. 54; Aachen exhibition 1965, cat. E 105; Corpus (ph. 6599).

NOTES: 1. M. -M. Gauthier, 'Emaux et orfèvrerie', Limousin Roman, (Ed. Zodiaque) Saint-Léger-Vauban 1963, 98–187, figs. 10–13; Corpus, vol. I, D 1, 5.
2. Kofler collection catalogue, E 105.
3. Gauthier 1978a, 23–9, figs. 1–10, 13.
4. Gauthier 1972, 184–8, cat. 45; Gaborit 1976, especially 243–6, figs. 8–15.

## 22   Candlestick (plate 19).

*Champlevé enamel on copper. H. 26.2 cm; foot 12.7 cm × 11.8 cm. Limoges, about 1195–1205.*

Six pieces of metal, slotting into each other: a pyramidal base with three feet, cylindrical shaft in two sections divided by a spherical knop, drip-pan with depression for catching the wax, conical spike. Beaten copper, *champlevé*, engraved, gilded. The six sections are threaded onto a central copper pin. Enamel: ultramarine blue, azure blue; red, green, purple; yellow; white; in single or mixed fields. Typical features are: the figures reserved and encrusted with enamel; the decorative elements enamelled or reserved, with the borders of their fields punched; the backgrounds studded with reserved motifs, distributed symmetrically on the foot, knop and drip-pan; the claw feet beneath lion masks. However, the decoration of the foot of no. 22 is unusual: it combines big multi-coloured palmette flowers on the three sides of the base, set against purple grounds, with small dragons reserved and filled with red enamel, against blue grounds. In spite of this unusual combination, no. 22 is related to the early work of the Limoges ateliers.[1]

PROVENANCE: nineteenth to twentieth century, collection of the Princes of Liechtenstein, Château de Vaduz; before 1964 to 1971, Kofler collection (inv. 678); 1971–, Keir collection.

LITERATURE: Zürich exhibition 1964, cat. 902, pl. 101; Kofler collection catalogue E 108, pl. 24; Aachen exhibition 1965, cat. E 108, pl. 77; Corpus, vol. II (ph. 1368, 6519).

NOTES: 1. Corpus, vol. I; C2, 1 (Modena, Museo Civico); E3, 12 and D1, 3 (both Jerusalem, Studium Biblicum Franciscanum, Archeological Museum); D1, 4 (Florence, Bargello); E3, 11 (Bern-Riggisberg, Abegg-Stiftung); G1, 9 (Munich, Bayerisches Nationalmuseum); G1, 10 (New York, Metropolitan); G1, 11 (Schloss Sigmaringen); G1, 12 (Dijon, Musée des Beaux-Arts).

## 23   Candlestick (figure 4).

*Champlevé enamel on copper. H. 19.3 cm; Diam. of foot 7 cm. Limoges, about 1200.*

Six sections, slotting into each other: spherical domed base, with three feet; cylindrical shaft divided by a knop, made up of two shells of metal; drip-pan with recessed centre for catching the wax; conical spike. Bent copper sheets, embossed, *champlevé*, engraved, chased; traces of gilding. Slotted onto a single central copper pin, riveted beneath the base and ending as the spike at the top. Enamel: dark blue, bright blue; red-black, green, turquoise; yellow; in single or mixed fields. Enamel with reserved decoration on foot, knop and drip-pan, gilded engraving on the stem, plain gilding beneath the drip-pan. On the base the decoration radiates from the stem: four discs with pearled edges surround irregular quatrefoils, with blue centres against 'cloud' grounds of red-black, green, yellow; the discs alternate with palmettes, whose big curling leaves are of blue and turquoise against a blue ground. On the drip-pan, eight gilded semicircles with blue grounds are decorated with trefoils of blue, green and yellow, disposed alternately against the border and against the spike. *Vermiculé* gilded scrollwork on the stem and on the knop, where it is enamelled with two tones on blue. Of the known repertory of Limoges candlesticks, only seven (including two pairs), all dating from the end of the twelfth century, have a base of this form, a domed sphere with three feet.[1]

PROVENANCE: Pierre Peytel collection, Paris; before 1964 to 1971, Kofler collection (inv. 678 D); 1971–, Keir collection.

LITERATURE: Zürich exhibition 1964, cat. 903; Kofler collection catalogue E 109, pl. 56; Aachen exhibition 1965, cat. E 109; Corpus, vol. II (ph. 4565).

NOTE: 1. Rupin 1890, 517–26; Corpus, vol. I, E 3, 12; D 1, 4; E 3, 11; G 1, 12 (for locations, see no. 22, note 1).

## 24   Quadrilobed plaque: an angel (figure 6).

*Champlevé enamel on copper. H. 13.5 cm; W. 13.5 cm. Limoges, about 1250–60.*

Quadrilobed plaque, with four pinholes. *Champlevé*, engraved, enamelled and gilded. Enamel: ultramarine blue; red, green, turquoise; yellow; white; in single and mixed fields. Figure reserved on enamelled ground, with vegetal motifs reserved and decorated with veining. Circular central 'glory' of turquoise with a white framing band, around a bust-length angel with a lobed green and yellow nimbus. Dressed in a dalmatic and mantle, and holding a book, the angel emerges from clouds, which are enamelled in a range dominated by green. The gilded plants of the background are the same as those in the four lobes, where, however, they are set against a blue ground.

The plaque is probably from a *châsse*. Of course this

type of angel is very popular with the Limoges coppersmiths of the thirteenth century,[1] but particularly so on *châsses* with an opening roof. The plaques of this type which decorate the backs of crosses are small and do not have the circular central field (e.g. a plaque in the Keir collection, which is not exhibited: Kofler, E 54). However a similar plaque, which may even come from the same object as no. 24, was bought in 1880 from the Stein collection by the Musée des Beaux-Arts, Lyon (inv. 78).[2] The works which suggest a date about 1250 or a little later for the Keir plaque are: the *châsse* of St Viance, at St Viance (Corrèze),[3] and the plaque from the altar of l'Artige-aux-Moines (Haute-Vienne), near Limoges (now in Warsaw), which is inscribed and dated 1267.[4]

PROVENANCE: before 1904, Bourgeois collection, Cologne, and Harry Fuld collection, Frankfurt-on-Main; before 1955, Clan-Mallière collection, Paris; before 1964 to 1971, Kofler collection (inv. 650V); 1971–, Keir collection.

LITERATURE: Bourgeois sale, Math. Lampertz(?), Cologne, 19–27 October 1904, lot 381; Hôtel Drouot sale, Paris, 19 November 1955, lot 61; Zürich exhibition 1964, cat. 868; Kofler collection catalogue E 64, pl. 41; Aachen exhibition 1965, cat. E 64; *Corpus*, vol. IV (ph. 6591).

NOTES: 1. Rupin 1890, 332–5.
2. Charles Stein sale, Galerie Georges Petit, Paris, 11 May 1886, perhaps lot 63.
3. Gauthier 1950, pls. 48–50.
4. M. -M. Gauthier, 'La plaque de dédicace émaillée datée de 1267 d'un autel jadis à l'Artige, aujourd'hui au musée national de Varsovie, et les autels de l'Artige', *BSAHL*, LXXXVII, 3, 1960, 333–48 (with fig.).

## 25   Incense boat (figure 5).

*Champlevé enamel on copper. H. 5.8cm; W. 8.6cm; L. 18.2cm. Limoges, in the 'style of Paris', late thirteenth century.*

Liturgical vessel, an almond-shaped 'boat', for storing incense. Flattened ovoid foot. The lid is in two pieces, one of which lifts on a hinged pin across the centre. Two handles in the form of snakes. Copper sheets cut out and embossed, then *champlevé*, enamelled, engraved; traces of gilding. Enamel: medium blue, red, turquoise; in single fields. Reserved figures and decorative motifs on enamel grounds. On the 'boat', pairs of fantastic creatures are arranged symmetrically on the two sides. They are engraved in quatrefoil medallions, alternately of turquoise and red enamel. On each half of the lid, a three-quarter-length angel in a circular glory, with three enamelled discs in the spandrels enclosing small heads, some hooded. Although numerous incense boats were produced in the course of the thirteenth century,[1] very few were decorated with enamel on the 'boat' itself; no. 25 is therefore unusual.

The figures on the lid belong to a type of decoration which already appears about 1210–16 on the Limoges incense boat in the parish church of Neuenbecken (Westphalia).[2] But the grotesques and small hooded heads, as well as the specific use of combinations of blue and red enamel, suggest the influence of northern French Gothic.

PROVENANCE: before 1906, Schevitch collection, Paris; after 1906, Octave Pincot collection, Paris; before 1964 to 1971, Kofler collection (inv. 679 B); 1971–, Keir collection.

LITERATURE: Schevitch sale, Galerie Georges Petit, Paris, 4–7 April 1906, lot 205; Zürich exhibition 1964, cat. 910; Kofler collection catalogue E 116, pl. 59; Aachen exhibition 1965, cat. E 116; *Corpus*, vol. V (ph. 6575–6).

NOTES: 1. A Darcel, 'Navettes à encens des XIIe et XIIIe siècles', *Ann. archéol.* XIV, 1854, 263–7; Rupin 1890, 537–41.
2. J. Braun, *Das Christliche Altargerät*, Munich, 1932, 639, fig. 548.

## 26   Pyx (figure 5).

*Champlevé enamel on copper. H. 11cm; Diam. 6.5cm. Limoges, mid-thirteenth century.*

Cylindrical, with conical lid topped by a cross. The hinge and clasp are incomplete. The bottom has tenon and mortise joints. Copper strips embossed and bent, *champlevé*, engraved, enamelled and gilded. Enamel: blue; green, red, turquoise; yellow; white; in single or mixed fields, unusual for their combinations of two tones (deep blue-white, green-white, dark blue-yellow). Ornament reserved and hatched, on enamelled grounds studded with reserved motifs. The top is reserved and gilded. Body and lid are decorated with simple stems enclosing large multi-coloured palmette flowers and turquoise enamelled discs around four-petalled flowers. Among the pyxides which have survived in France, thirteen belong to a series with running stems, cf. particularly a pyx in the Ashmolean Museum, Oxford (M 237); for stems and discs combined, cf. British Museum MLA OA 225 (exhibited here).[1]

PROVENANCE: G. Chalandon collection, Lyon and Paris; before 1964 to 1971, Kofler collection (inv. 677B); 1971–, Keir collection.

LITERATURE: Zürich exhibition 1964, cat. 913; Kofler collection catalogue E 128, pl. 71; Aachen exhibition 1965, cat. E 128; *Corpus*, vol. IV, 3 (ph. 6595).

NOTE: 1. Rupin 1890, 201–21; M. Bilimoff, 'Pyxides d'origine limousine conservées en France', Mémoire de Maîtrise (typescript), Université de Paris IV, Sorbonne, 1978–9, 12 (note 58), 64, fig. 167 (Oxford), 54, fig. 158 (B.M.).

## 27   Candlestick (figure 4).

*Champlevé enamel on copper. H. 23cm. Limoges, about 1205–15.*

Six pieces of metal, slotting into each other; pyramidal base with three feet, cylindrical shaft in two sections divided by a spherical knop, drip-pan with depression for catching the wax, conical spike. Thick copper plates are bent and embossed, *champlevé*, engraved and chased; traces of gilding. The six sections are threaded onto a central copper pin. Enamel: dark blue, azure blue, bright blue; red, green; yellow, white; in single or mixed fields. Base with borders of fields tooled; figures, grounds and decoration all enamelled. Knop and drip-pan enamelled, with some reserved motifs. Stem and feet

engraved. On the base, the decoration radiates, with three blue segments: filled by an animal with four feet and a long tail, and edged with a 'cloud' motif; multi-coloured foliage trails in the spandrels. Claw feet, beneath lion masks. On the knop, *vermiculé* foliage scroll, encrusted with blue enamel. Drip-pan with two-coloured 'cloud' motif. Several hundred Limoges candlesticks of this type were produced in the first half of the thirteenth century.[1]

PROVENANCE: before 1964 to 1971, Kofler collection (inv. 678C); 1971–, Keir collection.

LITERATURE: Zürich exhibition 1964, cat. 904; Kofler collection catalogue E 110, pl. 56; Aachen exhibition 1965, cat. E 110; *Corpus*, vol. II (ph. 4584).

NOTE: 1. Rupin 1890, 517–26; J. Braun, *Das christliche Altargerät*, Munich, 1932, 492–530, figs. 377–80.

## 28 Châsse, with hinged roof (figure 6).

*Champlevé enamel on copper. H. 8.8cm; W. 7.8cm; D. 4.1cm. Limoges, about 1280–95.*

Casket, with pitched roof and gabled ends, on four tall feet. The roof opening on two hinges, with a catch; crowned by three modern crystals. Copper plates cut out and embossed, then *champlevé*, engraved, enamelled and gilded, without wooden core, fixed with mortise and tenon joints. Enamel: deep blue, bright blue; red, turquoise; white, in single or mixed fields. Reserved figures engraved on enamelled grounds decorated with reserved motifs, the edges of their fields and the feet punched. Same decoration on roof as below: two half-length angels with red haloes emerge from multi-coloured clouds against a turquoise or red ground within roundels. Spandrels· blue, with gilded foliage trails. On the gabled ends a similar medallion below, a smaller angel in the triangular space on the roof above.

In the second half of the thirteenth century this type of Limoges *châsse* was produced in large quantities: strongly put together from copper plates, the colours repetitive (blues, reds, turquoises and whites), decorated with angels in roundels.[1] One hundred or so survive today, mainly in France, and often in the smaller churches, e.g. Aixe-sur-Vienne (Haute-Vienne), Lamontjoie (Lot-et-Garonne), Lunegarde (Lot), Rocamadour (Lot).[2]

PROVENANCE: Nanteuil collection, then the collection of Gruel, book-binder, Paris; before 1964 to 1971, Kofler collection (inv. 670 P); 1971–, Keir collection.

LITERATURE: Zürich exhibition 1964, cat. 834; Kofler collection catalogue E 8, pl. 32; Aachen exhibition 1965, cat. E 8; *Corpus*, vol. V.

NOTES: 1. Rupin 1890, 332–5; *Corpus*, vols. IV and V; Victoria & Albert Museum, London, 236–1853, 816–1891, 573–1910. 2. *Corpus*, vol. IV.

## 29–30 Two medallions from a casket (figure 7).

*Champlevé enamel on copper. Diam. (a) 9cm; (b) 8.9cm. Limoges, second quarter of the thirteenth century.*

Round plaques, each with four pinholes. Copper plates, their borders *champlevé* and enamelled, their centres *repoussé*, chased and then cut out in openwork. Enamel: single fields of dark blue and bright blue. Figures in low relief, engraved, hatched and gilded. Borders with reserved motifs on enamelled grounds. The figures are fantastic hybrids, each with two feet, the head and torso of a monkey, two wings sprouting from the head, and a scaly tail developing into a foliage scroll with palmette leaves. One creature grips the branch and a wing, the other a round shield as well as the foliage stem. On the border, inside a band of light blue, little tufted leaves alternate with small buds on a dark blue ground. In Piedmont, several caskets are or were decorated with similar medallions.[1] See also twelve medallions given by Larcade to the Louvre.[2]

PROVENANCE: Larcade collection, Paris; before 1964 to 1971, Kofler collection (inv. 650 Q 1); 1971–, Keir collection.

LITERATURE: Zürich exhibition 1964, cat. 863, 865; Kofler collection catalogue E 60, E 61, pl. 40; *Corpus*, vol. IV (ph. 6570, 6571).

NOTES: 1. L. Malle, 'Antichi smalti cloisonnés e champléves del sec. XI-XIII in raccolte e musei del Piemonte', II. 'Champléves limosini e italiani del secolo XIII', *BSPABA*, new series, IV-V, 1950–51, 80–122. 2. P. Verlet, 'Donation Larcade. Douze disques de Limoges', *Bulletin Musées France*, XV, 1950, 6, no. 1.

## 31 Medallion: an archer (figure 7).

*Champlevé enamel on copper. Diam. 4.4cm. Limoges, about 1240–50.*

Round plaque, with three pinholes, enamelled with a single deep blue ground, and gilded. The figure and background motifs are reserved, the border reserved and hatched. The archer is in profile to the right, between two plants, and holds his bow in one hand while pulling an arrow from his quiver with the other. This secular subject-matter suggests that the plaque formerly decorated a small box or casket.[1] In style, it is related to a very worn *ampulla* decorated with a siren (BM.MLA 94, 2–17, 8; unpublished, exhibited here) and a spice-box (Boston, Museum of Fine Arts, inv. 55.418). A much earlier plaque (*c*.1200) with similar secular subject-matter is also in the British Museum (MLA 78, 11–1, 3, exhibited here).

PROVENANCE: before 1952, Mutiaux collection, Paris; before 1964 to 1971, Kofler collection (inv. 650E); 1971–, Keir collection.

LITERATURE: sale of Colonel W[ild] Estate and the Mutiaux collection, Hôtel Drouot, Paris, 14 March 1952, lot 106; Zürich exhibition 1964, cat. 854; Kofler collection catalogue E 50, pl. 38; Aachen exhibition 1965, cat. E 50; *Corpus*, vol. IV (ph. 6592).

## 32   Châsse of St Valerie and St Martial (plates 20–21, figure 8).

*Champlevé enamel on copper. H. 17cm; W. 15cm; D. 5.9cm. Limoges, about 1270–80.*

Casket, with pitched roof and gabled ends, on four tall, narrow feet. The cresting is trapezoidal, pierced with eight lobed holes and with three crowning projections. The door in the back, with keyhole, shuts at the bottom. Six copper plates cover a wooden core, the four big rectangular plates with eight pinholes, the front feet now uncovered: *champlevé*, enamelled, engraved and gilded. Enamel: royal blue; red, black, turquoise; yellow; white, in single fields but with a few touches of black, blue, white and red, turquoise, yellow. Figures reserved and engraved, buildings and furniture enamelled against enamelled grounds decorated with reserved motifs.

The scenes relate to the two principal local saints of the Limousin, St Martial, the Apostle of Aquitaine, and St Valerie, the patron saint of the Dukes of Aquitaine from the Merovingian period onwards.[1] Reading from top to bottom, left to right: front (roof), martyrdom of St Valerie, in two scenes divided by a crenellated tower with white enamelled pointed doorway. Left, *intra muros*, the saint is condemned, standing in the centre and counting on her fingers, before the seated proconsul; one of her executioners holds her by the shoulders, the other with a spear points towards: right, the martyrdom scene in two episodes, with the saint led out of the city, and kneeling before her executioner's raised sword. Front (below), again two scenes, divided by the springers of two arches: left, the executioner Hortasius struck by lightning, the proconsul seated on a throne of red, turquoise and white bands, and holding a flowering sceptre; right, the saint carrying her own severed head kneels before St Martial in his bishop's mitre, behind him is an altar covered with a white cloth and adorned with a chalice and burning candlesticks. Back (roof), miracles of St Martial, in two scenes divided by a turquoise border: left, St Martial saves the naked soul of Hortasius from hell, spewed from the mouth of a devil with horns, another devil with a fork emerging, above, from white waves (?), perhaps the river Styx; right, a man possessed of a devil and held in chains by a figure behind, is exorcised by the saint's benediction. In these two scenes, St Martial demonstrates his powers as a healer both on earth and beyond the grave. Back (below), the conversion of 'Tève le Duc': a *disputatio* with Duke Stephen and St Martial seated facing each other; their chairs have red, white and turquoise bands, the tree between them is crowned with a multi-coloured palmette leaf. St Martial is dressed as a bishop with mitre and yellow halo, Stephen wears a flat cap. On each

gable-end a bishop saint stands, blessing with his right hand and holding a crozier or a cross-staff.

There are very few historiated *chasses* surviving from the third quarter of the thirteenth century. No. 32 is therefore a rarity, perhaps evidence of a revival of the cult of St Valerie at Limoges or even of a renewed distribution of her relics. An unpublished related *chasse* is in the Museum at Toledo, Ohio (50.249). See also the *chasse* of St Francis, recently sold in London.[2] The chronology of the group can be established by its relationship with the dedication plaque from the altar of l'Artige-aux-Moines (Haute-Vienne), which is dated 1267.[3]

P. C.

PROVENANCE: before 1843, acquired by Abbé Jacques Texier of Limoges and later Le Dorat; passed to his brothers Rémi and Hubert; Fayette collection, Limoges; before 1913, Georges Dormeuil collection, Paris; before 1952 to 1971, Kofler collection (inv. 670); 1971–, Keir collection.

LITERATURE: Abbé Texier, 'Essai sur les argentiers et émailleurs de Limoges', *Mémoires de la Société des Antiquaires de l'Ouest*, 1843, 134–6, pl. v; Ardant 1855, perhaps resembling the casket described on p. 424; Ch. de Limas, 'La Châsse de Gimel et les anciens monuments de l'émaillerie', *BSSHA de la Corrèze*, v, 1883, 136n; Louis Guibert, 'L'Orfèvrerie limousine et les émaux d'orfèvre à l'exposition rétrospective de Limoges', *BSAHL*, XXXV, 1888, 214; Rupin 1890, 399–403, figs. 458–9; Paris exhibition 1900, cat. (orfèvrerie) 2449; G. Migeon, 'L'Exposition rétrospective, L'art à l'Exposition Universelle de 1900', *Revue de l'Art Ancien et Moderne*, Paris 1900, 62 (cited); Paris exhibition 1913, cat. pl. XLIX; Gauthier 1955, 62; Zürich exhibition 1964, cat. 829; Gauthier 1955; Kofler collection catalogue E 4, pls. 4, 5, 28; Aachen exhibition 1965, cat. E 4, pls. 57–8; *Corpus*, vol. v (ph. 1369 –70, 6525–6, 9642–5).

NOTES: 1. M. -M. Gauthier, 'Première campagne de fouilles dans le "Sépulcre" de Saint-Martial de Limoges', *Cahiers Archéologiques*, XII, 1962, 205–48; Gauthier 1955. 2. *Corpus*, vol. IV (Toledo); Sotheby's sale, London, 9 July 1981 (St Francis *chasse*), lot 223. 3. M. -M. Gauthier, 'La plaque de dédicace émaillée datée de 1267 d'un autel jadis à l'Artige, aujourd'hui au musée nationale de Varsovie, et les autels de l'Artige', *BSAHL*, LXXXVII, 3, Limoges 1960, 333–48.

## 33   Plaque: the Virgin Mary (figure 7).

*Champlevé enamel on copper. H. 7.4cm; W. 9cm. Limoges, second quarter of the thirteenth century.*

Rectangular plaque from the arm of a cross, curving and broadening to a squared-off terminal at the left. Copper plate, cut out, *champlevé*, hatched and engraved, enamelled and gilded. Enamel: lapis blue, bright blue; green, red; pink-white; in single fields, with edging colours or mottled. Figure enamelled with reserved areas, on a hatched ground with reserved motifs. The border enamelled. The Virgin Mary, half-length with nimbus, her head bowed to her left, her hands clasped together in a typical gesture of sorrow, such as is common in representations of the Crucifixion. Flesh tones in translucent pink-white, her veil blue, edged with white and draped over her shoulders, her blue mantle with broad sleeves. The figure breaks into the frame and the nimbus is cut off. Two large eight-pointed stars and a quatrefoil are engraved in the gilded ground.

The border is enamelled blue and mottled with red.

Star patterns on gilded grounds are characteristic of a well-known family of Limoges enamels,[1] e.g. the *châsse* with scenes of the Childhood of Christ in the National-museet, Copenhagen (9101–3–101), which was made for the Scandinavian market, or the Bonneval Cross, recently acquired by the Musée de Cluny.[2] These works can be dated because of their relationship to reliquaries with the scene of the Stigmatisation of St Francis of Assisi, e.g. Louvre OA 4083;[3] many relics of St Francis were distributed in the years following the Stigmatis-ation (1224) and before his death (1226).

PROVENANCE: before 1964 to 1971, Kofler collection (inv. 650P); 1971–, Keir collection.

LITERATURE: Zürich exhibition 1964, cat. 855; Kofler collection catalogue E51, pl. 38; Aachen exhibition 1965, cat. E51; *Corpus*, vol. III (ph. 1375).

NOTES: 1. W. F. Stohlman, 'The star group of champlevé enamels and its connections', *Art Bulletin*, XXXII, 4, 1950, 326–9.
2. M. -M. Gauthier, 'La croix émaillée de Bonneval au Musée de Cluny', *La Revue du Louvre et des Musées de France*, 4, 1978, 267–85, fig. 23, figs. 1–3.
3. Gauthier, *Revue du Louvre* 1978, fig. 29.

# 34 Almond-shaped plaque: an angel (figure 7).

*Champlevé enamel on copper. H. 3.4cm; W. 1.6cm.*
*Limoges, second quarter of the thirteenth century.*

Two large holes through plaque. *Champlevé*, engraved, enamelled; traces of gilding. Standard range of colours, in single or mixed fields. Figure reserved on an enamel-led ground, with punched designs for the decorative enamelled details. Bust-length angel, on a blue ground, with several colours used for the 'clouds' and discs of the background. Perhaps from the middle of one of the arms on the reverse side of a cross, cf. the crosses in the Musée des Beaux-Arts, Dijon (1256), and the Walters Art Gallery, Baltimore (44.76).[1]

PROVENANCE: before 1952, Mutiaux collection, Paris; before 1964 to 1971, Kofler collection (inv. 650D); 1971–, Keir collection.

LITERATURE: Sale of Colonel W[ild] Estate and the Mutiaux collection, Hôtel Drouot, Paris, 14 March 1952, lot 106; Zürich exhibition 1964, cat. 857; Kofler collection catalogue E53, pl. 38; Aachen exhibition 1965, cat. E53; *Corpus*, vol. IV (ph. 6584).

NOTE: 1. Thoby 1953, nos. 60, 65.

# 35 Gemellion, with courtly scenes and shields of arms (figure 9).

*Champlevé enamel on copper. Diam. 24cm; H. (at the spout) 4.8cm. Limoges, about 1240–60.*

A gemellion (from *gemellus*, twin) is a bowl, one of a pair, used for washing hands on ritual or ceremonial occasions. In the inventories, they are also referred to as *urceoli*, *cyphi*, *bacini*. The interior has figures and decoration reserved on enamelled grounds; the exterior is engraved and was originally gilded. The interior has a series of scenes of courtly recreation, arranged around a central medallion with a shield of arms (azur serre of fleurs de lys or sans nombre, for France ancien) sur-rounded by three dragons. From the medallion five lobes radiate, each with a white border, ultramarine blue ground, reserved gilded foliage stems and two figures, the one on the right seated on a turquoise enamelled bench, the other standing and playing a musical instru-ment. Clockwise, from left: 1. a woman playing the bagpipes and a seated woman, one hand on her breast, the other gesturing towards the border; 2. a woman playing a psaltery and reciting; 3. a woman playing the vielle to a man holding a flowering staff; 4. a woman dancing with castanets, while a man holds a flowering staff and is probably reciting; 5. a woman playing the harp to a man holding a flowering staff.[1] In the span-drels, small shields of arms: 1. for Burgundy; 2. for Vendôme ancien(?); 3. for Angoulême; 4. for Dreux-Brittany; 5. unidentified (countervair three pallets azure). The edge is decorated with a twisted ribbon motif, on a blue or green ground.

The secular and courtly subject-matter of this bowl (music and dancing, amorous conversation), alternating as it does with armorial bearings, can also be found on certain caskets with enamelled medallions, where fabu-lous animals just like the three dragons of the gemellion also occur, cf. the enamelled casket in the Aachen Treasury, dating from 1250.[2] These courtly scenes can be found on about thirty gemellions dating from the period 1220–50, whereas the shields appear only on the later members of the 'courtly group'. Some sixty gemel-lions, however, are decorated with shields, either in the centre, in the lobed fields or in the spandrels; by the end of the thirteenth century they have taken over all these areas. The engraved decoration of the exterior is also organised to radiate from a central medallion, with a lion passant surrounded by intersecting segments of circles, forming a star with foliate terminals and stars in the spandrels. Nearly all Limoges gemellions are deco-rated on the exterior with an exclusively engraved and gilded arrangement of radiating, often heraldic, motifs, even if they show considerable variety in how the elements are disposed. For the intersecting segments of no. 35, cf. a gemellion in the Musée Départementale de l'Allier at Moulins, which in its turn is similar to another gemellion in the Keir collection, not exhibited here.[3]

PROVENANCE: 1952, in the collection of the Princes of Liechtenstein, Château de Vaduz, testified by the modern inscription carefully handwritten in ink and the label on the back with the monogram v S V (Schloss von Vaduz); before 1964 to 1971, Kofler collection (inv. 669); 1971–, Keir collection.

LITERATURE: Marquet de Vasselot 1952, no. 36; Gauthier 1954, 387 and fig.; Zürich exhibition 1964, cat. 916; Kofler collection catalogue E118, pl. 61; Aachen exhibition 1965, cat. E118; *Corpus*, vol. IV, 3 (ph. 1372, 2549, 11918–9).

NOTES: 1. S. Champeaux-Dufeutrelle, 'Les gemellions limousins du XIIIe siècle à scènes de musique et de danse', Mémoire de maîtrise (typescript), Université de Paris IV, Sorbonne, 1979–80, II, cat. 39 and fig. p. 49.
2. M. Pastoureau, *Traité d'héraldique*, Paris, 1979, 37–55, fig. 268; M. -M. Gauthier, 'Danseuses et musiciens, motifs romans au seuil de

l'art gothique', *Atti del Convegno Romanico Europeo*, Modena, 1977 (forthcoming); J. B. de Vaivre, 'Le décor héraldique de la cassette d'Aix-la-Chapelle', *Aachener Kunstblätter*, 45, Aachen, 1974, 97 –124.
3. Marquet de Vasselot 1952, nos. 42–3; Kofler collection catalogue E 117, pl. 60.

## 36   Gemellion, with rider and shields of arms (figure 10).

*Champlevé enamel on copper. Diam. 22.3cm. Limoges, about 1250–70.*

For the word 'gemellion', see no. 35; here, the absence of a spout means that this was the bowl to receive the water poured from its lost pair. The interior has figures and decoration reserved on enamelled grounds; the exterior is engraved and gilded.

The interior has a central medallion, with a horseman carrying a lance and galloping towards the right, on an arched ground-line. A star with six spokes radiates from this medallion, with turquoise enamelled grounds, gilded reserved plants and multi-coloured flowers on the border. The six segments between the spokes of the star have gilded foliage branches against ultramarine blue grounds, framing a shield of arms: (clockwise) 1. un-identified (vairy or and azure); 2. unidentified (party per jess vert and or a lion counterchanged a baton gules overall); 3. for Angoulême? (lozengy or et vert); 4. unidentified (bendy or and gules, in chief on white enamel a lion passant or); 5. for Lusignan; 6. for Turenne? (party per pale dexter azure a demi eagle or sinister bendy of eleven argent and gules).

The edge is decorated with zigzags on a blue ground, the exterior with a radiating composition: eight-spoked star and central motif, sixteen spandrel areas with a scale pattern. Of the approximately 230 Limoges gemel-lions which are known, only a few have a decoration formed from a spoked star pattern, and these usually also have shields of arms.[1] No. 36 is comparable to another gemellion in the Keir collection, not exhibited here, particularly for its central rider figure, but the six spokes of the star have become eight and the six border segments are suppressed.[2] Cf. also two gemellions in the Museos de Arte, Barcelona, with a central rider and an arrangement of eight radiating shields.[3]

PROVENANCE: until nineteenth century, Taurin collection, Rouen; before 1964 to 1971, Kofler collection (inv. 668 A); 1971–, Keir collection.

LITERATURE: Marquet de Vasselot 1952, no. 103; Zürich exhibition 1964, cat. 918 (Review: Lasko 1964, fig. 14); Kofler collection cata-logue E 120, pl. 63; Aachen exhibition 1965, cat. E 120; *Corpus*, vol. v (ph. 2611, 6569, 12050–1).

NOTES: 1. Marquet de Vasselot 1952, nos. 12, 13, 14 (figures); nos. 102, 103 (coats of arms).
2. Kofler collection catalogue E 119, pl. 62.
3. Marquet de Vasselot 1952, nos. 106, 119; Barcelona inventory 4572; 4575.

## 37   Two plaques, from an altar tabernacle (plate 22 (interior), figure 11 (exterior)).

*Champlevé enamel on copper. (A) H. 33.4cm; W. 14.5cm; (B) H. 33cm; W. 7.4cm. Limoges, about 1270.*

Two elements from a five-part altar tabernacle. It stood originally on a square base, with three walls of equal dimensions, the fourth opening up by means of two symmetrical shutters. Plaques A and B are of the same height, but B is only half the width of A, while the profile of the pointed section at the top of B coincides exactly with half of the pointed section at the top of A: B was therefore a shutter. On one edge of A, two small ungilded areas are found at the same height as two original attachment marks on the opposite edge, i.e., they are hinge marks. Plaque B has been cut down by 4mm at the bottom but still has traces of hinges at the same levels, where it pivotted. On its long edge are four holes through which a vertical strip was attached to cover the junction between B and its lost counterpart shutter. Therefore B was the right-hand shutter.

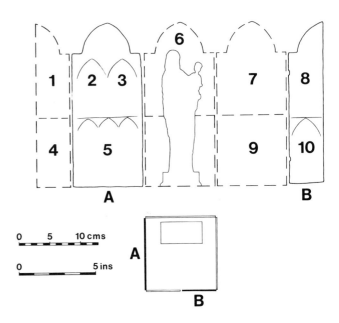

Copper sheets *champlevé*, enamelled and gilded on a single side, suggesting that this was the richly decorated inner face. On the exterior they are simply engraved and gilded. Enamel: dark blue, azure blue; red, deep bronze green, intense green and blue; white; the grounds in single fields, but some of the ornaments in mixed fields (blue-white, greenish blue-red). Interior, with figures, decoration and borders reserved and engraved on an enamel ground with motifs reserved and veined. Ex-terior, with figures and decoration reserved and en-graved against chequered grounds with plain or hatched motifs. Given the symmetry that must have governed the walls of the tabernacle, it is not difficult to reconstruct visually the lost shutter and the other two walls, cf. the translucent enamel and silver tabernacle of Parisian

origin now in the Museo Poldi-Pezzoli, Milan: it opens in five parts and presents the same contrast between the richly coloured and the purely decorative surfaces.[1] From the surviving two plaques, the following reconstruction of the lost parts may be proposed (see diagram): they were in two registers like A and B, divided horizontally by 'cloud' motifs; they were given the same gilded architectural settings, with single or twin arcades on colonnettes or corbels; their spandrels were decorated with the same little lanterns, with red windows, their roofs developing into branches of foliage. On A, from top to bottom, are shown the Virgin of the Annunciation, the Visitation and the three Magi of the Adoration (diagram nos. 2, 3 and 5), and on B the Annunciation to the Shepherds and the Virgin of the Presentation in the Temple, holding the candle of the Purification (nos. 8 and 10). On the lost plaques: in two registers, on the plaque to the left of A (above) the archangel Gabriel (no. 1); below, either Herod or the horses of the Magi (no. 4); to the right of A, the Virgin and Child receiving the offerings of the Magi, perhaps assisted by Joseph or angels (no. 6), undoubtedly the major group of the tabernacle, occupying the centre of the altarpiece to its full height, either as an applied group in relief or a statuette fully in the round. Cf. the group of the tabernacle in the Santa Casa at Loretto;[2] on the right side wall: below, Simeon receiving the Child in the Presentation scene (no. 9); above, the Nativity (no. 7), which would have been succeeded by the Annunciation to the Shepherds (no. 8).

The tabernacle therefore presented a similar series of scenes to those carved on the earliest Paris ivory tabernacles;[3] these have a standing figure of the Virgin in the centre, flanked in two registers on their folding leaves by Infancy scenes, often with figures from one scene spreading over onto a neighbouring panel. Here then a Limoges workshop can be seen adopting, by about 1270, a Parisian fashion.[4] The lost Virgin of no. 37 could have been enthroned, like the Majesty of the Blumka collection in New York,[5] but it is also possible that Limoges had already adopted the standing figure of the Virgin with Child, precisely to play the central rôle in tabernacles of this type: in the Musée du Perigord, there is such a standing figure, although it is somewhat later in date; it comes from the neighbouring church of Notre-Dame des Vertus (Dordogne).[6]

PROVENANCE: *Plaque A*: before 1 June 1885, Abbé Julien Gréau collection, Lyon; before 28 April 1910, Cottreau collection, Paris; before 1938, Mortimer L. Schiff collection; 1938–, Philip Nelson collection, Liverpool;
*Plaque B*: Comtesse de Béhagues collection, Paris; by 1947, Philip Nelson collection;
*Both plaques*: before 1960 to 1971, Kofler collection (inv. 650 U); 1971–, Keir collection.

LITERATURE: *Plaque A*: Abbé J. Gréau sale, Hôtel Drouot, Paris, 1–9 June 1885, lot 1240, pl. XLV; Rupin 1890, 502, fig. 556–7 (shown with four hinges); Cottreau sale, Galerie Georges Petit, Paris, 28–9 April 1910, lot 44 and fig.; M. Hamel, 'La Collection Cottreau', *Les Arts*, no. 100, April 1910, 13 and pl. 7 (shown framed); Mortimer L. Schiff sale, Christie's, London, 22–3 June 1938, lot 93 (shown 'in moulded ebony frame');
*Both plaques*: P. Nelson, 'A Limoges enamel triptych of the thirteenth century', *Transactions of the Historic Society of Lancashire and Cheshire*, 99 (for 1947), 1949, 24–30; Cologne exhibition 1960, cat. 97, pl. 78; Zürich exhibition 1964, cat. 850, pl. 89; Kofler collection catalogue E 44, pl. 18; *Corpus*, vol. V (ph. 907, 6604–8, 8198).

NOTES: 1. Gauthier 1972, 256–60, cat. 207.
2. Gauthier 1970, 92; E. Bertaux, 'L'Esposizione d'Orvieto e la storia delle arti', *Archivio storico dell' arte*, 1896, 411–13.
3. Koechlin 1924, nos. 134, 140, 142, 154–6, 165, pls. XXXVII-XLI.
4. C. Little, 'Ivoires et art gothique', *Revue de l'Art*, 1979, 58–67, no. 46, figs. 10, 12.
5. *Corpus*, vol. V (ph. 13878–81).
6. *Corpus*, vol. V (ph. 9234–7).

## 38 Rectangular plaque, with the Virgin Mary between two saints (plate 23).

*Cast copper, champlevé enamel on copper, gilt silver filigree, cabochons. H. 15 cm; W. 16.8 cm. Paris workshop, in a Limoges tradition, about 1290–1310.*

Copper plaque probably from the side of a house-shrine. Two rows of three pinholes, top and bottom. Architectural setting, with four buttresses dividing three pointed arches (H. 12 cm; W. 4.5 cm) which are framed by continuous applied strips, around figures also applied in high relief (H. 7.4 cm; 8 cm; 7.5 cm). Behind the second buttress, where its pinnacle is broken away, an assembly mark: B. Above the apex of the central arch, a stamped mark: R, perhaps with a crown. Originally, top and bottom borders probably also had applied strips, since the gilding is very worn in these areas. Copper plate, *champlevé*, enamelled and gilded. Enamel: ultramarine blue; red, greenish blue, white; in single fields, some with reserved motifs. Applied figures and architecture of copper (or an alloy of copper), cast, chased and gilded. Framing strips of gilt silver, with twisted filigree work forming scrolls and leaves around settings for *cabochons*, a few lost or replaced. In the centre, the Virgin Mary crowned stands on a moulded corbel, the Child on her left arm, a broken sceptre in her right hand. To her right, St John the Baptist holding a medallion with the Lamb, in accordance with his prophecy of Christ's Passion, and clothed in raiment of camel's hair. To her left, a nimbed bishop, blessing with his right hand.

In structure the buttresses, with plinth, base, setbacks, gables and flowered pinnacles, are the exact counterparts on a miniature scale of monumental prototypes. This architectural decoration as well as the introduction of tracery patterns and of figures in relief is typical of enamellers working in a Limoges tradition in Paris about 1300.[1] So too is the contrasting use of red and blue enamel, and the introduction of heraldic motifs. The figures all stand, with a slight thrust of the hip, their draperies arranged in a gentle series of curving parabolas, cf. certain ivory carvings of the period.[2] No. 38 can therefore be attributed to a Parisian goldsmith's workshop as far as the figures are concerned. As to the enamel, it is very probable that this also was executed in Paris, about 1280–1300. The metal bookcover of Sankt Paul in Levanthal may be invoked, as an example of this style in the Upper Rhineland.[3]

PROVENANCE: Chalandon collection, Lyon; before 1964 to 1971, Kofler collection (inv. 650 N); 1971–, Keir collection.

LITERATURE: Cologne exhibition 1960, cat. 98; Zürich exhibition 1964, cat. 878, pl. 95; Kofler collection catalogue E 85, pl. 20; Aachen exhibition 1965, cat. E 85, col. pl. p. 156.

NOTES: 1. Gauthier 1972, 192–4 and 377–9, cat. 142–7.
2. Koechlin 1924, pls. CVIII-CIX, cat. 657 (Musée de Cluny, Paris), 659 and 660 (Bayerisches Nationalmuseum, Munich).
3. Heuser 1974, 128–31 (no. 13), pls. 114–26.

## 39  Clasp (figure 12).

*Champlevé enamel on copper. H. 12.5cm; W. 12.5cm. Limoges work in the Parisian manner, for the Papal Court at Avignon(?), second quarter of the fourteenth century.*

Quadrilobed plaque, with ogee and 'spiked' circumference (top left section broken off). A central and two side plates, divided by joining strips, corresponding to an attachment pin on the back. Three figures in low relief, chased, gilded and applied to the copper plates, which were cut out, *champlevé*, enamelled and gilded. Blue enamel ground, with decoration reserved. The three standing saints are nimbed, the left one a woman, the central one wearing a cope, the right one bearded, wearing a chasuble. The background is diapered with an alternating pattern of *fleurs de lys* on a blue ground, and red enamelled rosettes on a hatched reserved ground.

A late Limoges production, this is one of a whole series of clasps of variable quality. The figures with their angular Gothic draperies reflect Parisian models, which influenced Limoges ateliers either by direct contact or as a result of the patronage of the Papal Court at Avignon.[1] Clement VI (1342–52) was a native of the Limousin.

PROVENANCE: before 1964 to 1971, Kofler collection (inv. 704 A); 1971–, Keir collection.

LITERATURE: Zürich exhibition 1964, cat. 880; Kofler collection catalogue E 86, pl. 44; Aachen exhibition 1965, cat. E 86; Gauthier 1972, mentioned in cat. 146; *Corpus*, vol. VI (ph. 1377).

NOTE: 1. Gauthier 1972, 379 (cat. 146).

## 40  Statuette: the Archangel Gabriel, from an Annunciation (figure 13).

*Brass. H. 16.8cm. Picardy, Artois or southern Flanders, about 1260–70.*

Cast brass, in high relief. Youthful standing male figure, frontal, with his hair softly modelled to frame his round face; short nose, almond-shaped eyes, a 'smile' playing about his closed lips. The silhouette of the figure is contained and slim, with shoulders tapering and feet close set. His arms are also contained within the silhouette, crossed in front of his body, the index finger of his right hand extended. Perhaps this is the moment of the Annunciation made with a gesture of unusual intimacy, the scroll falling from his left hand among the descending drapery folds of his mantle. The draperies are broadly treated with generous pockets and strong

contours, different in this respect from the stone and wood sculptures which acted as models for the brass no. 40.[1]

PROVENANCE: before 1908, Octave Homberg collection, Paris; before 1964 to 1971, Kofler collection; 1971–, Keir collection.

LITERATURE: Migeon 1904, 37 and fig.; Octave Homberg sale, Galerie Georges Petit, Paris, 11–16 May 1908, lot 545; Zürich exhibition 1964, cat. 935; Kofler collection catalogue E 141, pl. 81.

NOTE: 1. J. Lestocquoy, *Quelques anges artésiens du XIIIᵉ siècle*, reprinted: J. Lestocquoy, *L'Art de l'Artois. Etudes sur la tapisserie, la sculpture, l'orfèvrerie, la peinture*, Arras, 1973, 58–60, pls. XXI-XXV.

## 41  Virgin and Child (figure 13).

*Repoussé copper, gilded. H. 14.6cm; W. 6.8cm. Limoges, third quarter of the thirteenth century.*

Applied figure, in low relief, with six holes for attachment, three on each side of the seat. Single copper sheet, cut out, *repoussé*, engraved and gilded. No enamel. Chiselled and punched patterns. The Virgin Mary is crowned and enthroned, in a long robe with a mantle and orphrey bands. She holds the Child on her left knee, and a round fruit in her right hand. The Child is almost standing, blessing, with a book in his left hand. The Virgin as the *Sedes Sapientiae* (Throne of Wisdom) is often represented on croziers, back to back with an image of Christ, though of course on a smaller scale. She also appears as such in a series of statuettes, the so-called Majesty groups, cf. no. 19.[1]

The dimensions of no. 41 and its attachment holes suggest that it comes from a *châsse*. Already, about 1250, on the *châsse* in the church of St Viance (Corrèze), the characteristic 'smile' is introduced.[2] This feature is typical of the third quarter of the thirteenth century.

PROVENANCE: Philip Nelson collection, Liverpool; before 1964 to 1971, Kofler collection (inv. 651D); 1971–, Keir collection.

LITERATURE: Zürich exhibition 1964, cat. 896; Kofler collection catalogue E 102, pl. 53; Aachen exhibition 1965, cat. E 102; *Corpus*, vol. V (ph. 1049, 4591).

NOTES: 1. Hildburgh 1955; Gauthier 1970.
2. Gauthier 1972, cat. 133.

## 42  Medallion: St Demetrius (plate 23).

*Cloisonné enamel on gold. H. 3.8cm. Byzantine, ninth or tenth century.*

Round plaque, edge damaged to left and to right. Originally set into a liturgical object, the frame of an icon, a woven gold orphrey or a reliquary capsule. Gold plaque, *cloisonné*, fully enamelled: cobalt blue; red, green, greenish yellow, black, turquoise; brownish yellow; pinkish white; in single tones, and more or less opaque. Frontal, beardless, nimbed figure, bust-length, holding a cross in front of his breast, two red crosses on

holds a cross but has a disc inscribed *Exaltatio* in his other hand.[1] A winged Virtue shown frontally is a common type, for example cf. two Mosan plaques in the British Museum of *Fides* and *Religio* (MLA 78, 11–1, 15–16, exhibited in Medieval Gallery Case 4). Closest to no. 47 in iconography is a plaque with a winged Virtue holding a crown and inscribed *Caritas*, formerly in the collection of Dr Leopold Seligmann of Cologne, present whereabouts unknown;[2] it is smaller than no. 47 and therefore unlikely to come from the same object. Although no rectangular Virtue plaques survive as the upper and lower terminals of a cross, if the remade cross in the Victoria and Albert Museum is excluded, it has been suggested that no. 47 may have occupied such a position because of its shape and size. The attributes held by *Humilitas* seem to be a direct reference to the Passion of Christ, but it is equally possible that it comes from a reliquary or book-cover, rather than from a cross.[3] No. 47 is a work of outstanding quality, the drawing of the head comparable in style to the Christ at the top of the Alistair Bradley Martin True Cross reliquary-triptych in New York.[4]

<div align="right">N. S.</div>

PROVENANCE: by 1933. Adolphe Stoclet collection, Brussels, then Philippe R. Stoclet; 1970–, Keir collection.

LITERATURE: Comte J. de Borchgrave d'Altena, 'Des figures de Vertus dans l'art mosan au xiie siècle', *Bulletin des Musées Royaux d'Art et d'Histoire*, 3rd series, 5th year, no. 1, Brussels, January 1933, 17 and fig. 16; A. Katzenellenbogen, *Allegories of the Virtues and Vices in Medieval Art...*, London, 1939, 48–9 (note 2); P. Verdier, 'Un monument inédit de l'art mosan du xiie siècle. La crucifixion symbolique de Walters Art Gallery', *Revue Belge d'Archéologie et d'Histoire de l'Art*, xxx, 1961, 154, fig. 25; Morgan, 1973, 273 (note 66).

NOTES: 1. Verdier, 144, fig. 20.
2. *Die Sammlung Dr Leopold Seligmann, Köln*, sale Hermann Ball, Paul Graupe, Berlin, 29 April 1930, no. 125d.
3. Morgan 1973.
4. Metropolitan Museum of Art, catalogue: *Medieval Art from Private Collections*, 30 October 1968 to 30 March 1969, no. 149.

---

## 48 Plaque: Moses and the brazen serpent (plate 23).

*Champlevé enamel on copper. H. 7cm; W. 9.5cm.*
*Mosan, third quarter of the twelfth century.*

Rectangular plaque, with four beaded edges, four corner pinholes, one pinhole in centre of upper edge (not original?), four holes through plaque haphazardly distributed and not original. Hammered, edges tooled, *champlevé*, enamelled, engraved and gilded. Enamel: azure blue, pale blue; turquoise, green, yellow; white, in single or mixed fields. Within a 'frame' of pale blue-white, Moses (inscription MOISES) stands to the left, advancing and gesturing towards the brazen serpent (inscription SERPENS) raised on a pole, with two Israelites to the right. The episode (cf. Numbers xxi, 9), very common in Mosan art as an antetype of the Crucifixion, is commented by the inscribed scroll in Moses' left hand: MIST(e)RIU(m).CRUCIS.

Features found in other versions of the scene are the balanced composition of figures on either side of a central pole, and the serpent with the head of a dog. The foliage sprouting from the base of the pole is without parallel. The palette with its combinations of green-turquoise, green-yellow, pale blue-white is low key; red is wholly absent, cf. the plaques on a cross in Brussels.[1] The drawing is of high quality. Belts, cuffs and the fold over Moses' right knee are delicately engraved with criss-cross or lozenge patterns in the reserved metal. Numerous typological plaques have survived detached from their original settings, e.g. a similarly drawn plaque in the British Museum (MLA 56, 12–17, 1 – Medieval Gallery, Case 4). No. 48 was probably the terminal of a cross.[2] Whether or not it comes from the same object as plaques in the Walters Art Gallery, Baltimore[3] and the Hermitage Museum, Leningrad,[4] has still to be determined, but it is stylistically related to the former. Palette, drawing style, and the engraved motifs on garments are common to both and are in turn related to the Mosan enamels on the 'Peter side' of the shrine of St Heribert in Cologne-Deutz.[5]

<div align="right">N. S.</div>

PROVENANCE: before 1905, Chalandon collection, Lyon; before 1958 to 1971, Kofler collection; 1971–, Keir collection.

LITERATURE: Migeon 1905, 26 and fig. p. 19; Paris exhibition 1952, cat. 81; H. Swarzenski, 'The Song of the Three Worthies', *Bulletin of the Boston Museum of Fine Arts*, LVI, Boston, 1958, 33; Cologne exhibition 1960, cat. 80; Zürich exhibition 1964, cat. 839, pl. 82 (Reviews: Lasko 1964, 10; Demoriane 1964, 97 with col. pl.); Kofler collection catalogue, E14, pl. 10; Aachen exhibition 1965, cat. E14; G. Chapman, 'Jacob Blessing the Sons of Joseph. A Mosan Enamel in the Walters Art Gallery', *The Journal of the Walters Art Gallery*, XXXVIII, Baltimore, 1980, 34–6 and 55, fig. 2 and App. II (pp. 57–8).

NOTES: 1. Brussels, Musées Royaux d'Art et d'Histoire, inv. 2293, see S. Collon-Gevaert, J. Lejeune, J. Stiennon, *A Treasury of Romanesque Art*, London, 1972, no. 38.
2. Morgan 1973, 265.
3. P. Verdier, 'Emaux mosans et rheno-mosans dans les collections des Etats-Unis', *Revue Belge d'Archéologie et d'Histoire de l'Art*, XLIV, 1975, 32–4; Chapman 1980, 34–6, 57–8, figs. 1–2.
4. Morgan 1973, 273, note 55; J. Lafontaine-Dosogne, 'Oeuvres d'art mosan au Musée de l'Ermitage à Leningrad', *Revue Belge d'Archéologie et d'Histoire de l'Art*, XLIV, 1975, 94–6, fig. 3; Chapman 1980, 55, note 1.
5. H. Schnitzler, *Rheinische Schatzkammer. Die Romanik*, Düsseldorf, 1959, pls. 93–5; Kofler collection catalogue, 16 (E 14 n.).

---

## 49 Plaque: Solomon, David and Jesse (figure 14).

*Champlevé enamel on copper. H. 4.6cm; W. 10.6cm.*
*Mosan, third quarter of the twelfth century.*

Rectangular plaque, chamfered sides, vertically cut top edge and beaded lower edge, four corner pinholes. Hammered, lower edge tooled, *champlevé*, enamelled, and gilded. Enamel: azure blue; green, turquoise, yellow; red; white; in single and mixed fields. Three figures, bust-length, identified by vertical inscriptions in blue enamel, as + SALOMON/DAVID/+IESSE, all nimbed, David crowned. Heads and hands reserved, their engraving filled with blue enamel; draperies, haloes and 'frame' enamelled, on a reserved ground.

The drawing style, palette and combination of tones are typical of a whole series of Mosan enamels of the third quarter of the twelfth century. The low broad format of the plaque suggests that it was made for the border of e.g. a book-cover[1] or portable altar. A plaque, exhibited in the Musée de Cluny (Louvre OA 1075), has three similarly rendered figures, the prophets Isaiah, Jeremiah and Ezekiel; it is identical in style and dimensions to no. 49 and probably comes from the same object.[2] Given that it also has only a single beaded lower edge and that its inscriptions are lettered to be read with the plaque standing on its left side, it must come from the right border of the object, while no. 49 must come from the lower border. Jesse with David and Solomon as his two successors belongs to the genealogy of Christ (Matthew I, 5–7), perhaps to an abbreviated Tree of Jesse composition; the three prophets of the Musée de Cluny plaque could have acted as witnesses of Christ's genealogy, as so often in traditional renderings of Isaiah's famous prophecy (XI, 1–3).[3]

N. S.

PROVENANCE: before 1965, Adolphe Stoclet collection, Brussels, then Philippe R. Stoclet; 1965–1971, Kofler collection; 1971–, Keir collection.

LITERATURE: Sale collection Philippe R. Stoclet, Sotheby's London, 27 April 1965, lot 44; Kofler collection catalogue E 155, pl. 89; Morgan 1973, 270, 275 (note 157).

NOTES: 1. Morgan 1973. Cf. Liège, Musée Curtius, d'Arenberg book-cover (S. Collon-Gevaert et al., (see no. 48, note 1), no. 21.
2. J. -J. Marquet de Vasselot, Musée national du Louvre. Catalogue sommaire de l'orfèvrerie, de l'émaillerie et des gemmes . . . Paris 1914, no. 36: H. 4.5cm, W. 11cm, given to the Louvre in 1909 by Victor Gay; Morgan 1973; Archives Photographiques, cl. 14152.1.
3. A. Watson, The early iconography of the Tree of Jesse, Oxford and London 1934, passim.

## 50 Plaque: the symbol of St Matthew writing his Gospel (figure 14).

*Champlevé enamel on copper. H. 6.2cm; W. 3.8cm. Champagne (?), third quarter of the twelfth century.*

Rectangular plaque with four beaded edges, four corner pinholes. Cut-out for hinge on right edge, probably not original. On the reverse, mounting marks: a pair of diagonal incised lines. Subject-matter and hinge position suggest that at some date the plaque was attached to the top right-hand corner of a book-cover, with three corresponding Evangelist symbols in the other corners. Hammered, edges tooled, *champlevé*, enamelled, gilded. Enamel: azure blue, bright blue; red, green, yellow; deep green; grey, white; in single and mixed fields. The Evangelist is represented by his symbol, the winged man, (MAThEV, inscribed in blue on the reserved ground). He is seated with a writing desk on his knees, holding a knife in his left hand for preparing the parchment and dipping a quill into an ink pot to his right. His flesh parts and hair are reserved, their engraving filled with red enamel. His draperies are enamelled: mantle green-bright blue, tunic grey-white, with red neckband. Azure blue 'frame', cut by the halo of

green-yellow enamel. Writing desk azure blue-white, seat deep green, achieved by firing green and red glass together. Distinctive are the use of large areas of white as 'highlights' on the tunic, and the mottling of the wings with grey spots. The range of cool greys and whites contrasts strongly with the rich greens, blues and reds.

The intense white highlights and the red enamel filling the engraved features are not typical of the best-known groups of Mosan enamels. With its unusual palette, no. 50 was perhaps produced outside the main centres of Mosan enamelling, cf. an unpublished plaque with the Sacrifice of Isaac reset on a book-cover in the Bibliothèque Municipale at Sens and a plaque of *Fides* in the Cathedral Treasury at Troyes. The present state of research does not permit a definitive localisation of enamel workshops in Northern France, but a tentative attribution to Champagne in relation to a group of surviving enamels at Troyes may be proposed for no. 50.

N. S.

PROVENANCE: by 1972, Paris art market; 1972–. Keir collection.

Unpublished.

## 51 Ten plaques, from the base of an 'ymage' of the Virgin and Child (plate 24).

*Champlevé enamel on copper. (a) Two horizontal rectangular plaques. H. 5.8cm; W. 7.8cm. (b) Four vertical rectangular plaques. H. 5.7cm; W. 5.5cm. (c) Two trapezoidal plaques. H. 5.7cm; W. 7.9cm (top), 11.4cm (bottom). (d) Two trapezoidal plaques. H. 4.2cm; W. 1.2cm (top), 6cm (bottom). Southern Germany, region of Lake Constance, about 1340.*

Ten plaques, originally decorating the sides and sloping top of a base of irregular polygonal plan, arranged: on the sides, (a) together with two more lost horizontal rectangular plaques, in the wider fields; on the chamfered corners, (b); on the sloping top, (c) and (d), both with two more lost plaques to make up series of four, in the wider fields and on the chamfered corners respectively. Copper plates *champlevé*, enamelled and gilded. Enamel: cobalt blue; green, turquoise, red; yellow; white, in single fields or combined and fired together. Figures reserved, their engraving incrusted with enamel, on enamelled grounds decorated with enamelled motifs within reserved contours.

A plausible reconstruction would be (beginning with (b) and (a) on the sides):(1) St John Baptist as the precursor of Christ, with his disc showing the *Agnus Dei* and banner, and St Mary Magdalen with her vase of ointment; (2) Saints Margaret and Catherine, crowned, with their martyrs' palms and the instruments of their martyrdom, a dragon and a wheel; (3) the Annunciation, with the Archangel holding a long scroll and approaching from the left, the Virgin Mary with a book to the right, a lily flower in a vase between them and the dove of the Holy Spirit above; (4) the Virgin of the

Adoration, seated on a wide throne, holding a sceptre, with the Child standing on her knee making a gesture towards (5) the three Magi (on one of the plaques (a)), offering their gifts, a cup of gold, a horn of incense and a vase of myrrh; (6) the Presentation in the Temple, another scene of this now incomplete Infancy cycle, which includes a lamp suspended above the altar and apart from Simeon and the Virgin and Child, whose arms are extended in the form of a cross, the servant girl holding a candle and a basket with the sacrificial doves. On the sloping top of the base, prophets and patriarchs, bust-length, those of (c) identified by scrolls with inscriptions as: (7) Jacob and Habakkuk, and (8) Aminadab and Jeremiah, those of (d) unidentified. Cut in a technique reminiscent of silver *basse-taille*, the figures are modelled with deep pockets of red or dark blue enamel, set against an intense blue ground. The haloes and the little multi-coloured quadrilobes recall Limoges *châsses* of earlier periods.

The surviving plaques allow a reconstruction of the original layout, with an abbreviated Infancy cycle, such as that on the base of the Virgin and Child statuette, made for Jeanne d'Évreux,[1] or on the altar tabernacle no. 37. But these two objects, one Parisian, the other Limoges, have nothing in common stylistically with the present series of plaques, by a German artist whose language is strongly expressive, almost brutal in its accents. His draperies are engraved with a veritable network of folds so that the mass of his figures is subsumed in the density of the coloured enamel and their force and pathos communicated in the most direct manner. None of the other South German enamels of this period is strictly comparable to no. 51.[2]

PROVENANCE: before 1964 to 1971, Kofler collection (inv. 676 A); 1971–, Keir collection.

LITERATURE: E. Steingräber, 'Email', *Reallexikon zür Deutschen Kunstgeschichte*, v, 1959, 35–7, fig. 26; Zürich exhibition 1964, cat. 879, pl. 97; Kofler collection catalogue E 84, pl. 19; Aachen exhibition 1965, cat. E 84, pl. 72; Paris exhibition 1968, cat. 447; Gauthier 1972, 269 and 407, cat. 219 (with fig).

NOTES: 1. Gauthier 1973, 403, cat. 206.
2. Heuser 1974.

## 52 Central plaque from the front face of a cross, with the crucified Christ surrounded by symbols of the Cosmos (figure 16).

*Champlevé enamel on copper. H. 11.2cm; W. 9.6cm. Catalonia, about 1330–50.*

The cross from which the plaque was detached has recently been identified in the British Museum, together with three of the other four plaques from its front face (MLA 95, 12–25, 1):

(b) from top terminal of cross: censing angel. H. 8.1cm; W. 8.8cm.
(c) from bottom terminal of cross: Adam. H. 7.2cm; W. 8.8cm.

(d) from left terminal of cross: Virgin Mary. H. 8.8cm; W. 7.9cm.

The plaque from the right terminal remains untraced. The reverse of the cross is gilded and engraved with Christ in Majesty in the centre, the four Evangelist symbols on the terminals. Metallurgical analysis (1979)[1] and comparison of dimensions (March 1981) confirm the original position of no. 52 on the British Museum Cross, as suggested by M. -M. Gauthier.

Cross with broad curved trilobe terminals and a centrepiece of rectangular profile. On the arms are lobed projections. Rounded base spike for slotting into a processional staff or cross-foot. The copper plate of the cross is thin, without engraved decoration and gilded on its front face which was set originally with five enamelled plaques, of which four are now reassembled. The central plaque is a quadrilobe, the lower lobe longer than the other three. Of the four pinholes the top one is not original, the others placed as the three nail-holes through Christ's hands and feet. Enamel: lapis blue, red, green, no mixed fields. The figures are reserved, with enamelled line drawing.

The Crucifixion shown in a cosmic setting, with sun and moon and thirty-three stars corresponding to the thirty-three years of Christ's earthly life; two large roses, one to each side. The suffering Christ has no halo and is suspended without any cross to which the three nail holes can relate. His head, framed by long undulating strands of hair, is turned in three-quarter profile and sunk on his right shoulder. The rib-cage is drawn in schematic lines, forming a vivid contrast to the stretched abdominal muscles which are shown as rounded knots. The narrow silhouette of the figure has a marked swing which accentuates the effect of the broad deep folds of the loincloth above Christ's crossed legs and feet. IHS for *Ih(esu)s* inscribed on a diagonal 'panel' above Christ's head.[2] *Sol* full-face gilded (to the left), *Luna* in profile silvered (to the right), both with human features. The gilded stars of the background with their eight radiating points do not extend into the lower lobe. The three enamelled British Museum plaques, (b), (c) and (d), occupy the trilobe terminals; they are identical in style and technique with no. 52. Front face: at the top a censing angel, beneath Christ's feet Adam rising from the tomb, the central Crucifixion flanked by the standing figure of the Virgin Mary and (now lost) St John the Evangelist. Reverse, gilded and engraved: at the centre Christ in Majesty holding the terrestrial globe divided into three continents; the background studded with twelve stars, whose number must refer either to the twelve gates of the celestial Jerusalem (Apocalypse) or to the twelve Apostles (Gospels) or to the twelve months of the year (Cosmos). Number symbolism of this kind had a long tradition in Spain.[3] The Almighty is flanked by the four symbols of the Evangelists, standing with blank scrolls. The chequered ground of the bar of the cross is decorated with a double branch developing a series of alternating palmette leaves; this is not a purely ornamental motif, but represents the Tree of Life, cf. the branch of the Tree of Jesse on the enamelled front plaque with the Virgin Mary (d). Most of the decorative motifs are, however, haphazardly distributed, sometimes space-fillers, sometimes omitted altogether. It is

the figures who dominate: for instance, the wing feathers of the angel (b) and the Evangelist symbols (reverse) are hatched and sown with little crosses whilst two rosettes and eleven stars fill the space around the angel (b) and the Majesty (reverse). Yet little crosses and rosettes also appear on the Adam (c) and Virgin (d) plaques.

Stylistically, the engraved cross and the enamel plaques form a unity, governed by the same linear intensity which can be seen translating decorative motifs, draperies, gestures and faces into a common language of subtly varied patterns. Catalonia, closely in contact with Tuscan *trecento* art and with French Gothic, nevertheless remained original in the expressive force which continued to govern its stylistic traditions. This cross is the outstanding masterpiece among surviving fourteenth-century Catalan enamels.

PROVENANCE: 1895, the cross and three plaques from the front face acquired by the British Museum.
*Central plaque*: before 1906, in D. Schevitch collection, Paris; until 1944, in Cassel collection, Ruoms, Ardèche (France); confiscated during German occupation for a proposed museum to the glory of the Führer in Linz (Austria); 1945–56, identified in Munich at the 'collecting point' (B.1448) and returned to Baron Cassel; after 1956 and before 1960 to 1971, Kofler collection (inv. 650W); 1971, Keir collection; 1981, central plaque remounted on the cross for the duration of the current exhibition.

LITERATURE: *Central plaque*: Schevitch sale, Galerie Georges Petit, Paris, 4 April 1906, lot 207; Cassel collection catalogue 1956, cat. 212, pl. XXVII; Cologne exhibition 1960, cat. 99; Zürich exhibition 1964, cat. 864 (Reviews: Bloch 1964, 263; Demoriane, 1964, 92; Kauffmann 1964, 15; Lasko 1964, 464); Kofler collection catalogue E 59, pl. 40; Aachen exhibition 1965, cat. E 59; Gauthier 1972, 239, fig. 192; François 1981, 433–5, fig. 15; *Corpus*, vol. VI (ph. 10934, 19076, 20066–7).
*Cross*: Hildburgh 1946, 111 n. 2; François 1981, 433–5, fig. 14; *Corpus*, vol. VI (ph. 16540, 18673–4).

NOTES: 1. BM Lab. analysis 1/10/1979.
2. F. Hospital, 'Les inscriptions sur les croix dans l'oeuvre de Limoges', *102e Congrès National des Sociétés Savantes (archéologie)*, Limoges, 1977, 21–35.
3. P. de Palol, 'Une broderie catalane d'époque romane. La Genèse de Gérone', *Cahiers Archéologiques*, VIII, 175–214; IX, 219–51.

## 53 Rectangular plaque: the Last Supper (figure 16).

*Translucent basse-taille enamel on silver. H. 9cm; W. 8.8cm. Kingdom of Valencia, end of the fourteenth century.*

Almost square plaque, with four pinholes, probably from a processional cross. Silver plate *repoussé*, engraved, enamelled, with areas of gilding. Enamel: translucent blue and brown. Figures reserved and engraved, faces gilded and cut at varying depths, then filled with enamel. Lozenge pattern of ground either enamelled in blue and brown or gilded. Plain gilded border. The Last Supper is shown as a nearly circular composition, echoed at the top by a depressed arch on two columns, at the bottom by the curved form of the bench. Christ at the back in the centre is blessing with his right hand, while he holds a host in his left hand which is draped. He presides over the Apostles, seated around a

circular table on which bread, a flask of wine and bowls are set, with the Pascal Lamb on a dish in the centre. All the figures are nimbed except Judas, turning to his right at the bottom. Heads are shown frontally, in three-quarter or full profile, except for an Apostle at the bottom, whose back is completely turned to the spectator, and St John whose head rests on the table in front of Christ. The lozenge pattern of the table, engraved then enamelled blue, helps to create an effect of depth by dividing the composition spatially.

Several silver Catalan crosses, which were made in Barcelona or in the kingdom of Valencia, allow a reconstruction of the original function of no. 53, e.g. the cross at Jativa[1] and another in Gerona:[2] they have an extensive series of narrative scenes, and the Last Supper is usually placed at the centre of the cross-arms. A silver *basse-taille* enamelled plaque in the British Museum (MLA 85, 5–8, 2; unpublished) is exhibited here with no. 53.

PROVENANCE: Peytel collection, Paris; before 1964 to 1971, Kofler collection (inv. 683 A); 1971–, Keir collection.

LITERATURE: Zürich exhibition 1964, cat. 885, pl. 96 (Review: Lasko 1964, fig. 21); Kofler collection catalogue E 91, pl. 45; Aachen exhibition 1965, cat. E 91.

NOTES: 1. A. Marshall Johnson, *Hispanic Silverwork*, New York, 1944, 16–17, figs. 11–13; photo, Mas e H 556-e 71588.
2. Gauthier 1972, 232–44 and cat. 191, p. 398 (with fig.).

## 54 Belt (figure 12).

*Champlevé enamel on copper. Length 29.5cm; Diam. of medallions 2.2cm. Tuscany, about 1300.*

Chain of nine enamelled medallions, mounts with moulded rim and two attached ring-slots, ten circular links. Copper beaten out into flat round discs, the edges tooled to serve as settings for copper plates, which were *champlevé*, engraved, enamelled and gilded. Enamel: intense blue and red, in single fields or incrusted. Enamelled figures of fantastic animals in trefoils (from left to right): (1) animal with snail's body and eagle's head; (2) lion *passant* to the left; (3) bird *passant* to the left; (4) pecking wader, facing right; (5) bird with spread wings, facing left; (6) partridge *passant* to the left; (7) crouching lion, facing left and looking back. Also (8) veiled woman, holding a round fruit; (9) quadrilobe, with a lozenge-shaped centre.

These lively animals recall their counterparts, decorating the altar in the scene of the Presentation in the Temple, on the *paliotto* in the chapel of St James, in the Cathedral of Pistoia.[1] They are based on Northern European models, which were adopted in the second half of the thirteenth century in Tuscany.[2] The bust-length female figure, however, has something of the strongly modelled forms found in Sienese enamelling of the time of Guccio di Mannaia.[3] The scale of the medallions suggests that they were part of a belt, which has lost its buckle and catch. Very few secular belts have survived,[4] and given the numerous entries for such belts in fourteenth-century inventories, no. 54 is a rarity of considerable interest.

PROVENANCE: G. Chalandon collection, Lyon; before 1964 to 1971, Kofler collection (inv. 720E); 1971–, Keir collection.

LITERATURE: Zürich exhibition 1964, cat. 882; Kofler collection catalogue E 88, pl. 44; Aachen exhibition 1965, cat. E 88.

NOTES: 1. Gauthier 1973, 385, cat. 163.
2. Gauthier 1973, 204–32, and cat. 164 (Monstrance in the Victoria and Albert Museum, London 7546–1861).
3. Gauthier, 'Emaux Gothiques', British Museum enamels colloquium 3, 12–15 November 1980, *Revue de l'Art* 51, 1981 (forthcoming); W. Wixom, exhibition catalogue, 'Gothic Art 1360–1440', *The Bulletin of the Cleveland Museum of Art*, L, 7, Cleveland, September 1963, cat. 91 (and fig.).
4. V. Gay, *Glossaire Archéologique du Moyen Âge et de la Renaissance*, Paris 1883, fasc. 2, 291: *ceinture*. In the Keir collection, a second belt of nineteen medallions with Late Gothic lettering reserved in the enamelled grounds probably dates from the early fifteenth century in Italy.

## 55 Chrismatory (figure 15).

*Champlevé enamel on copper. H. 6.5cm; W. 9.2cm; D. 4.8cm. Rome (?), late thirteenth century.*

Container for holy oil, which is a mixture of olive oil and balm, blessed on Holy Thursday and used in certain of the sacraments (Baptism, Confirmation, Royal Coronation, Consecration of Bishops, of Altars and of Churches). In the thirteenth century the oil was sometimes kept in little rectangular caskets like no. 55, standing on bracket feet and with a cover of four panels bearing an articulated handle. The box is entirely of metal, the interior gilded, the exterior decorated with eight enamelled plaques, set within moulded borders. Copper plates *champlevé*, enamelled and gilded. Enamel: dark blue and red, in single fields, edged by narrow bands of metal, which look like the cell-work of certain *cloisonné* enamels. Figures enamelled against an enamelled ground with some reserved decorative motifs. On the front, the lock-slot, framed by two oak trees, divides the protagonists of the Annunciation: the Archangel Gabriel on the left against a blue ground is advancing towards the Virgin Mary, who is standing beneath an arch representing her chamber (*cubiculum*). On the back, the Crucifixion: Christ's head falls forward, his figure is twisted to his right and there is a diagonal foot-rest; he is attached by four nails to a wide cross, flanked by two angels kneeling in lamentation, and by the Virgin Mary and St John, their postures suggestive of acceptance and of the revelation of the redemption of mankind. On the ends, the Virgin and Child, and Christ in Majesty blessing and holding a book; both are shown half-length, icon-like. On the roof, four nimbed male saints, bust-length, between oak and vine branches, undoubtedly the Evangelists.

It is within the artistic milieu of late thirteenth-century Rome that parallels can be found for the Virgin's arch with its twisted decoration *all' antica*, for the unusual pair of angels prostrate at the foot of the cross, for the majestic and firmly drawn figures and the classicising heads of the Evangelists. The technique of the *champlevé* is of very high quality, the palette simple with only the intense blues and reds set off against the gilding. The figures are drawn with a directness and clarity which is remarkable. This is the finest example of the enameller's art to have survived from Rome during the period from the pontificate of Nicholas IV up to the death of Boniface VIII (1288–1303).[1]

PROVENANCE: before 1964 to 1971 Kofler collection; 1971–, Keir collection.

LITERATURE: Zürich exhibition 1964, cat. 834; Kofler collection catalogue E 9, pl. 32; Aachen exhibition 1965, cat. E 9.

NOTE: 1. Cf. the reused enamels on the casket in Santa Maria della Scala, Siena (Gauthier 1973, 205–17 and 387, cat. 165 with fig.).

# CONCORDANCE

Catalogue numbers with corresponding reference to the Kofler collection catalogue.

| | | | | | | | | | | | |
|---|---|---|---|---|---|---|---|---|---|---|---|
| 1. | E 156 | 12. | E 2 | 23. | E 109 | 34. | E 53 | 45. | E 87 |
| 2. | E 37 | 13. | E 3 | 24. | E 64 | 35. | E 118 | 46. | E 29 |
| 3. | E 94 | 14. | E 10 | 25. | E 116 | 36. | E 120 | 47. | – |
| 4. | E 7 | 15. | E 43 | 26. | E 128 | 37. | E 44 | 48. | E 14 |
| 5. | E 6 | 16. | E 42 | 27. | E 110 | 38. | E 85 | 49. | E 155 |
| 6. | E 41 | 17. | E 5 | 28. | E 8 | 39. | E 86 | 50. | – |
| 7. | E 107 | 18. | E 62 | 29. | E 60 | 40. | E 141 | 51. | E 84 |
| 8. | E 93 | 19. | E 1 | 30. | E 61 | 41. | E 102 | 52. | E 59 |
| 9. | E 40 | 20. | E 38 | 31. | E 50 | 42. | E 13 | 53. | E 91 |
| 10. | E 39 | 21. | E 105 | 32. | E 4 | 43. | E 12 | 54. | E 88 |
| 11. | E 11 | 22. | E 108 | 33. | E 51 | 44. | – | 55. | E 9 |

# ABBREVIATIONS

*Ann archéol*   *Annales archéologiques*, Paris
BM   British Museum
BM Lab. Analysis   British Museum Research Laboratory, unpublished metallurgical analyses
*BSAHL*   *Bulletin de la Société Archéologique et Historique de Limousin*. Limoges
*BSNAF*   *Bulletin de la Société Nationale des Antiquaires de France*. Paris
*BSPABA*   *Bollettino Società Piemontese di Archeologia e Belle Arti*. Turin

*BSSHA de la Corrèze*   *Bulletin de la Société Scientifique, Historique, et Archéologique de la Corrèze*. Brive
CNRA (Brussels)   Centre Nationale de Recherche Archéologique, Brussels
*Corpus*   M. -M. Gauthier, 'Corpus des émaux méridonaux', Centre Nationale de la Recherche Scientifique, Paris (to be published in five volumes)
MLA   Department of Medieval and Later Antiquities, British Museum

# EXHIBITIONS

AACHEN EXHIBITION 1965   'Mittelalterliche Kunst der Sammlung Kofler-Truniger', Luzern, Suermondt Museum, Aachen, 1965
BARCELONA EXHIBITION 1961   'L'Art Roman', Barcelona et Santiago di Compostella, Barcelona, 1961
BUENOS AIRES EXHIBITION 1951   'Exposicion, de Obras Maestras Siglo XII al XVII; coleccion Paula de Königsberg', Buenos Aires, 1951
COLOGNE EXHIBITION 1960   'Grosse Kunst des Mittelalters aus Privatbesitz', Schnütgen Museum, Cologne, 1960
LONDON EXHIBITION 1862   *Catalogue of the Special Exhibition of Works of Art of the Medieval, Renaissance and more recent periods on loan at the South Kensington Museum*, ed. J. C. Robinson, London, 1963
PARIS EXHIBITION 1865   'Exposition de l'Union Centrale des Beaux Arts appliqués à l'industrie', Paris, 1865
PARIS EXHIBITION 1884   'Exposition de l'Union Centrale des

Arts décoratifs', Paris, 1884
PARIS EXHIBITION 1900   'Exposition rétrospective de l'art français des origins à 1800', Paris, 1900
PARIS EXHIBITION 1913   'Objets d'art du moyen âge et de la Renaissance' (catalogued by Seymour de Ricci – no catalogue numbers), exhibition at Hôtel de Sagan, Paris, 1913
PARIS EXHIBITION 1951–2   'Trésors d'art de la vallée de la Meuse', Paris, 1951–2
PARIS EXHIBITION 1968   'L'Europe gothique, XII–XIVe siècles'. Twelfth exhibition of the Council of Europe, Paris, 1968
PARIS EXHIBITION 1979–80   'Le "Gothique" retrouvé avant Viollet-le-Duc', Hôtel de Sully, Paris, 1979–80
VATICAN EXHIBITION 1963   'Emaux de Limoges du moyen âge, églises et musées de France', Vatican City, 1963
ZÜRICH EXHIBITION 1964   E. and M. Kofler-Truniger collection exhibition, Kunsthaus, Zürich, 1964

# BIBLIOGRAPHY

ARDANT 1855   M. Ardant, *Emailleurs et émaillerie de Limoges*, Isle, 1855
BABELON *et al* 1980   J. P. Babelon, A. Chastel, A. Erlande-Brandenburg, P. Marot, P. Chapu, A. Leroi-Gourhan, 'Patrimoine français', editorial in *Revue de L'Art*, 49, Paris, 1980, 5–43
BLOCH 1964   P. Bloch, Sammlung E. und M. Kofler-Truniger, Luzern, *Kunstchronik*, XVII, 1964, 263 ff.
BLUNT 1867   A. Blunt, 'The history of Thomas Gambier Parry's collection', *The Burlington Magazine*, CIX (for March), London, 1967, 111–16
CAREY 1979   F. Carey, English 'Gothic Revival', *Le 'Gothique' retrouvé avant Viollet-le-Duc*, catalogue for Exhibition at Hôtel de Sully, Paris, 1979–80

CAUDRON 1976   S. Caudron, 'Emaux champlevés de Limoges et amateurs britanniques du XVIIIe siècle', *BSAHL*, CIII, Limoges, 1976, 137–68
CAUDRON 1977   S. Caudron, 'Connoisseurs of champlevé Limoges enamels in eighteenth century England', *British Museum Yearbook*, II, London, 1977, 9–33
CHAPMAN 1980   G. Chapman, 'Jacob Blessing the Sons of Joseph. A Mosan enamel in the Walters Art Gallery', *The Journal of the Walters Art Gallery*, XXXVIII, Baltimore, 1980, 34–55
CHAUDONNERET 1980   M. C. Chaudonneret, *La peinture troubadour, deux artistes lyonnais, Pierre Révoil (1776–1842), Fleury Richard (1777–1852)*, Paris 1980

CLARK 1928   K. Clark, *The Gothic Revival*, London, 1928 (many later editions up to 1962)

DALTON 1911   O. M. Dalton, *Fitzwilliam Museum, McLean Bequest Catalogue*, Cambridge, 1911

DARCEL 1883   A. Darcel, *Musée du moyen âge et de la Renaissance (Louvre) notice des émaux*, Paris, 1883

DARCEL & BASILEWSKY   A. Darcel and A. Basilewsky, *Catalogue de la collection Basilewsky*, Paris, 1874

DEMORIANE 1964   H. Demoriane, 'La collection Kofler dévoile ses trésors', *Connaissance des Arts* (for June), Paris, 1964, 92 ff

DU CANGE   Du Cange, entries under 'Limoges' in *Glossarium ad scriptores mediae et infimae latinitatis*, Paris, 1678 (and subsequently 1733–6, 1844, 1853–88)

D'EXPILLY 1762–70   Abbé d'Expilly, entries under 'Limoges' in *Dictionnaire géographique, historique et politique des Gaules et de la France*, Paris, 1762–70

VON FALKE 1928   Otto von Falke, *Alte Sammlung alter Goldschmiedewerke im Zürcher Kunsthaus*, Zürich, 1928

DE FLEURY 1878   Ch. Rohault de Fleury, *La Sainte Vierge, II, Etudes archéologiques et iconographiques*, Paris, 1878

FRANÇOIS 1981   G. François, 'Croix émaillées aragonaises au XIVe siècle, L'Oeuvre de Limoges et la chaîne pyrénéenne', *Actes du 104ᵉ Congrès national des Sociétés Savantes, Bordeaux, 1979*, Bordeaux, 1981, 423–40

FRANKL 1960   P. Frankl, *The Gothic, literary sources and interpretations through eight centuries*, Princeton, 1960

GABORIT 1976   J. -R. Gaborit, 'L'autel majeur de l'abbaye de Grandmont', *Cahiers de Civilisation Médiévale*, 3 (for July-Sept), Poitiers, 1976, 231–46

GAUTHIER 1950   M. -M. Gauthier, *Emaux limousins du XII an XIVe siècle*, Paris, 1950

GAUTHIER 1954   M. -M. Gauthier, 'Récentes études sur l'émaillerie champlevée de Limoges', *BSAHL*, LXXXIV, 3, Paris, 1954, 3–16

GAUTHIER 1955   M. -M. Gauthier, 'La légende de sainte Valérie et les émaux champlevés de Limoges', *BSAHL*, LXXXVI, 1, Limoges, 1955, 35–80

GAUTHIER 1957   M. -M. Gauthier, 'Les émaux, champlevés limousins et l'Oeuvre de Limoges, quelques problèmes posés par l'émaillerie champlevée sur cuivre en Europe méridionale du XIIe au XIVe siècle', *Cahiers de la Céramiques, du Verre et des Arts du Feu*, 8, Paris, 1957, 146–67

GAUTHIER 1958a   M. -M. Gauthier, 'Le décor vermiculé, l'émaillerie champlevée, origine et diffusion du motif au XIIe siècle', *Cahiers de Civilisation Médiévale*, 3, Poitiers, 1958

GAUTHIER 1958b   M. -M. Gauthier, 'Les émaux limousins champlevés', *Information d'histoire de l'art*, 3, 1958, 67–78

GAUTHIER 1960   M. -M. Gauthier, 'Emaux et orfèvrerie', *Limousin roman*, La Pierre-qui-Vire, 1960, 280–91

GAUTHIER 1963   M. -M. Gauthier, 'Le Frontal de san Miguel de Excelsis et L'Oeuvre de Limoges', *Art de France*, 3, 1963, 40–62

GAUTHIER 1966a   M. -M. Gauthier, 'Une châsse limousine du dernier quart du XIIe siècle; thèmes iconographiques, composition et essai de chronologie', *Mélanges René Crozet*, Poitiers, 1966, 937–51

GAUTHIER 1966b   M. -M. Gauthier, 'La Collection E. et M. Kofler-Truniger à Lucerne (Suisse) les émaux champlevés méridionaux', *BSAHL*, XCIII, Limoges, 1966, 19–34

GAUTHIER 1967a   M. -M. Gauthier, 'Le Goût Plantagenet et les arts mineurs dans la France du Sud-Ouest', *Akten des 21 Internationalen Kongress für Kunstgeschichte, Bonn, 14–19 September 1964*, I, Berlin, 1967, 139–55

GAUTHIER 1967b   M. -M. Gauthier, 'A Limoges champlevé book-cover in the Gambier-Perry collection', *Burlington Magazine*, CIX (for March), London, 1967, 151–7

GAUTHIER 1968   M. -M. Gauthier, 'Les reliures en émail de Limoges conservées en France, recensement raisonné', *Humanisme actif, Mélanges en l'honneur de Julien Cain*, I, Paris, 1968, 271–87

GAUTHIER 1970   M. -M. Gauthier, 'Les Majestés de la Vierge 'limousines' et méridionales, au Metropolitan Museum of Art de New York', *BSNAF* (for 13 March 1968), Paris, 1970, 66–95

GAUTHIER 1972 & 1973   M. -M. Gauthier, *Emaux du Moyen Age Occidental*, Fribourg, 1972 (2nd edition, revised, 1973)

GAUTHIER 1976   M. -M. Gauthier, 'Les inscriptions des émaux limousins', *BSNAF* (proceedings of 13 October 1976), Paris, 1976, 176–91

GAUTHIER 1978a   M. -M. Gauthier, 'Du tabernacle au retable, une innovation limousine vers 1230', *Revue de l'Art*, 40–41, Paris, 1978, 23–42

GAUTHIER 1978b   M. -M. Gauthier, 'Chronique, le Corpus des émaux méridionaux. Histoire des collections et chronologie artistique', *Cahiers de Civilisation Médiévale*, 21, 1, Poitiers, 1978, 87–94

GAUTHIER 1981   M. -M. Gauthier, 'Reliquaires du XIIIe siècle, entre le Proche-Orient et l'Occident latin: transports d'objets, transferts de formes', *Actes du Colloque international d'histoire de l'art*, section XIIIe siècle (for September 1979), Bologna, 1981

GROEDECKI 1979   L. Groedecki, in *Le 'Gothique' retrouvée avant Viollet-le-Duc*, catalogue for Exhibition at Hôtel de Sully, Paris, 1979–80

HEUSER 1974   H. J. Heuser, *Oberrheinische Goldschmiedekunst im Hochmittelalter*, Berlin, 1974

HIGHFIELD 1954   J. R. L. Highfield, *The Early Rolls of Merton College Oxford, with an Appendix of Thirteenth Century Oxford Charters*, Oxford, 1954

HILDBURGH 1936   W. L. Hildburgh, *Medieval Spanish Enamels*, Oxford, 1936

HILDBURGH 1946   W. L. Hildburgh, 'Note on a silver parcel-gilt cross from the Abruzzi', *Archaeological Journal*, CI (for 1944), London, 1946, 108–18

HILDBURGH 1955   W. L. Hildburgh, 'Medieval copper champlevé enamelled images of the Virgin and Child', *Archaeologia*, XCVI, London, 1955, 113–58

KAUFFMANN 1964   C. M. Kauffmann, 'The Kofler collection. An important exhibition in Zürich', *The Connoisseur* (for May), London, 1964, 15 ff

KOECHLIN 1924   R. Koechlin, *Les Ivoires Gothiques Français*, Paris, 1924 (reprinted 1968)

KOFLER COLLECTION   Collection of E. and M. Kofler-Truniger, Lucerne, Switzerland

KOFLER COLLECTION CATALOGUE   Herman Schnitzler, Peter Bloch, Charles Ratton, *Email, Goldschmeide-und Metallarbeiten, Europäisches Mittelalter, Sammlung E. und M. Kofler-Truniger, Luzern*, II, Lucerne and Stuttgart, 1965

KÖTZSCHE 1977   D. Kötzsche, 'Goldschmiedekunst', *Die Zeit der Staufer* (exhibition catalogue), Stuttgart, 1977, 391–482

LABARTE 1847   J. Labarte, *La collection Debruge-Duménil*, Paris, 1847

39

DE LABORDE 1852  L. de Laborde, *Notice des émaux ... musée du Louvre*, Paris, 1852

LASKO 1964  P. Lasko, 'A notable private collection', *Apollo* (for June), London, 1964, 464 ff

LEGROS 1775  L'abbé Legros, *Essai Historique sur Limoges et ses Environs*, Limoges, 1775

LEHNER 1872  F.A. von Lehner, *Fürstlich Hohenzollern'sches Museum zu Sigmaringen*, Sigmaringen, 1872

DE LINAS 1867  C. de Linas, 'L'Histoire du travail à l'exposition universelle de 1867' (II and IV-VII) *Revue de l'Art chrétien*, XI, Paris, 1867, 297–617

MARQUET DE VASSELOT 1906  J. -J. Marquet de Vasselot, 'Emaux limousins à fonds vermiculés, XIIe et XIIIe siècles', *Revue archéologique*, VI, no. 4, Paris, 1905 (reprinted with additions 1906)

MARQUET DE VASSELOT 1941  J. -J. Marquet de Vasselot, *Les Crosses limousins du XIIIe siècle*, Paris, 1941

MARQUET DE VASSELOT 1952  J. -J. Marquet de Vasselot, *Les Gémellions Limousins du XIIIe siècle*, Paris, 1952

MARTIN 1847–9  A. Martin, 'Ornements peints et émaillés', *Mélanges d'Archéologie*, I, Paris, 1847–9

MEYRICK 1836  S. Meyrick, 'Catalogue of the Doucean Museum', *The Gentleman's Magazine* (April-June), London, 1836, 100

MIGEON 1904  G. Migeon, 'Collection de M. Octave Homberg', *Les Arts*, 36 (for December) Paris, 1904, 33–48

MIGEON 1905  G. Migeon, 'La Collection de M. G. Chalandon', *Les Arts*, 42 (for June) Paris, 1905, 17–29

MOLINIER 1903  E. Molinier, *Collections du château de Goluchow* [Poland], *objets d'art du moyen âge et de la Renaissance*, Paris, 1903

DE MONTAULT 1867  Mgr X. Barbier de Montault, *La Bibliothèque Vaticane et ses Annexes*, Rome, 1867

MORGAN 1973  N. Morgan, 'The iconography of twelfth century Mosan enamels', *Rhein und Maas, Kunst und Kultur 800–1400*, 2, Cologne 1973, 263–78

PACAUD 1956  C. A. Pacaud, 'L'Abbé Jacques Texier (1813–1859)', *BSAHL*, LXXXVI, Limoges, 1956, 297–303

REUSSENS 1882  C. Reussens, 'Orfèvrerie et émaillerie', in Camille de Roddaz, *L'Art ancien à l'exposition nationale Belge*, Brussels and Paris, 1882

ROSENBERG 1921  M. Rosenberg, *Zellenschmelz: I Entstehung, II Technik, III Die Frühdenkmäler*, Frankfurt on Main, 1921

ROSS 1965  M. C. Ross, 'Jewelry, enamels and art of the migration period', *Catalogue of the Byzantine and Early Medieval Antiquities in the Dumbarton Oaks Collection*, Washington DC, 1965

RUPIN 1890  E. Rupin, *l'Oeuvre de Limoges*, Paris, 1890

SOUCHAL 1967  G. Souchal, 'Autour des plaques de Grandmont: une famille d'émaux limousins de la fin du XIIe siècle', *Bulletin Monumental*, CXXV, January-March 1967, Paris, 1967, 63–4

STOHLMAN 1939  F. Stohlman, *Catalogo del Museo Sacro Vaticano*, II, gli smalti, Vatican City, 1939

TEXIER 1857  Abbé J. T. Texier, *Dictionnaire d'orfèvrerie, de gravure et de ciselure chrétiennes*, Paris, 1857

THOBY 1953  P. Thoby, *Les Croix limousines de la fin du XIIe siècle au début du XIVe siècle*, Paris, 1953

WAY 1845  A. Way, 'Decorative processes connected with the arts during the Middle Ages. Enamel', *The Archaeological Journal*, II (for 1845), London 1846, 155–72

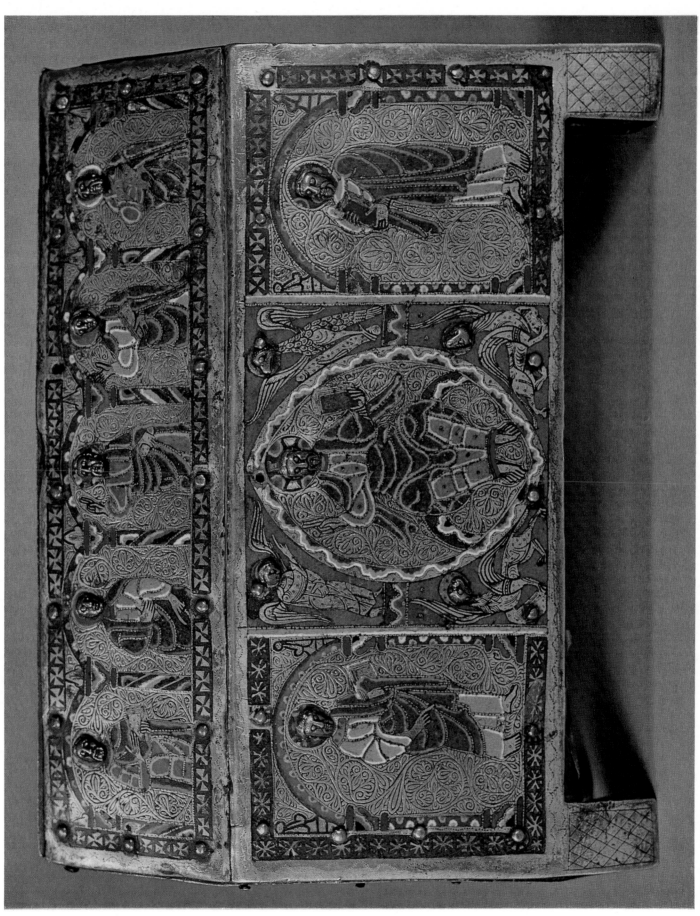

PLATE 1   CAT. NO. 1

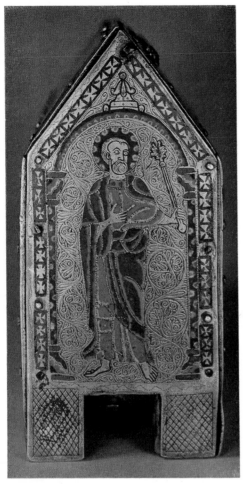

CAT. NO. 1

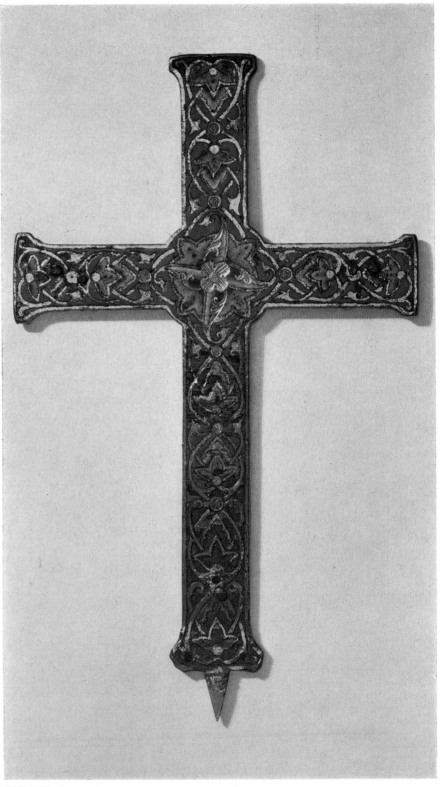

PLATE 2

CAT. NO. 3

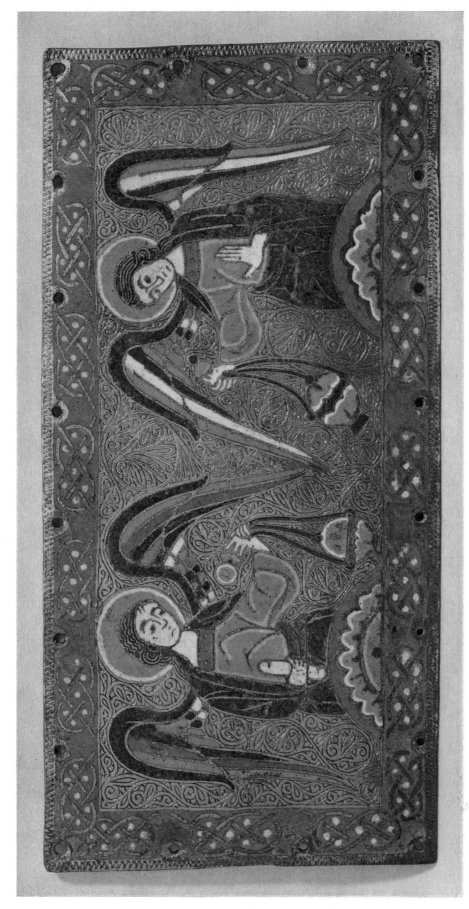

PLATE 3  CAT. NO. 2

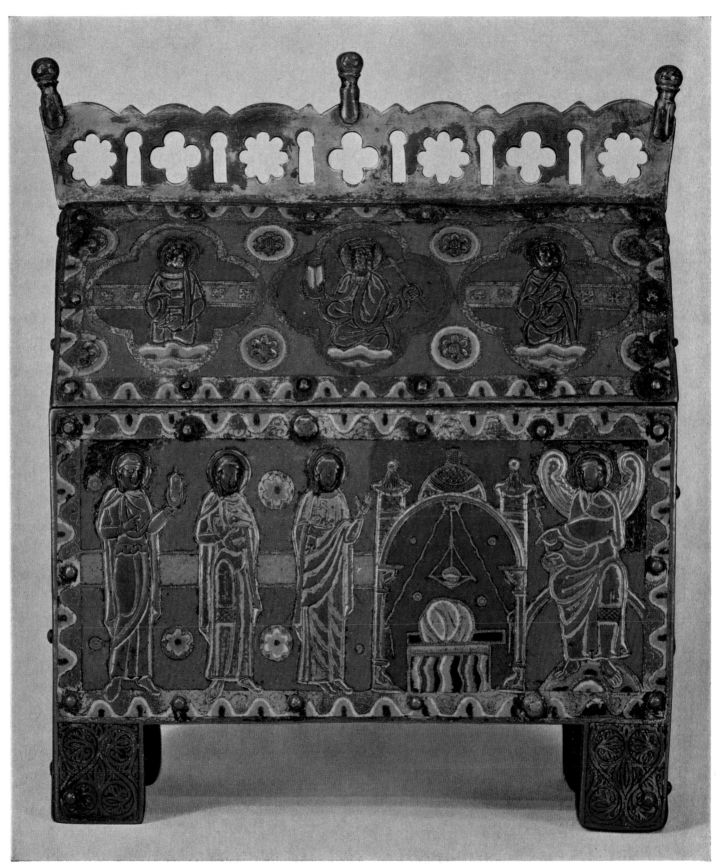

**PLATE 4  CAT. NO. 4**

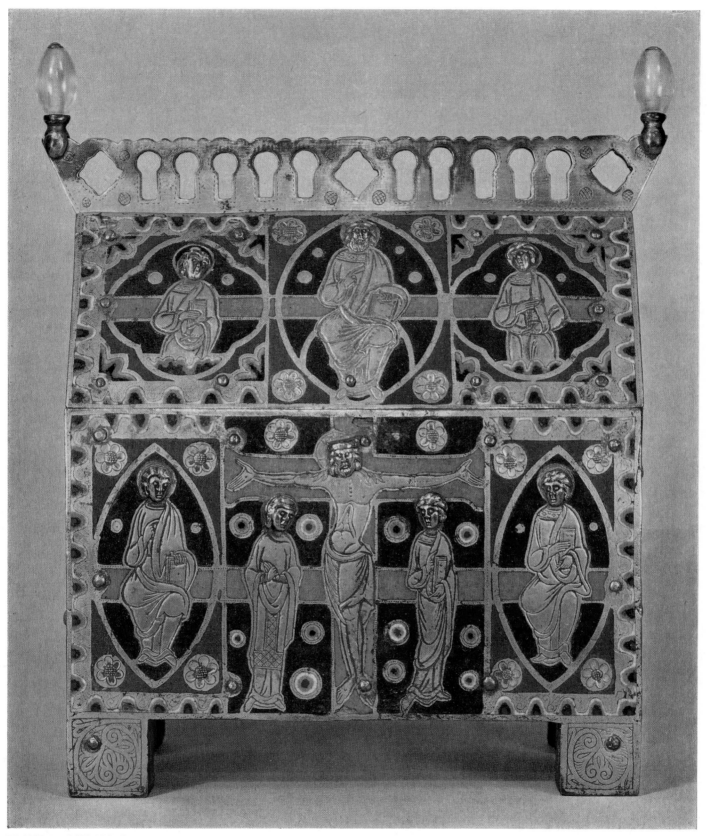

**PLATE 5  CAT. NO. 5**

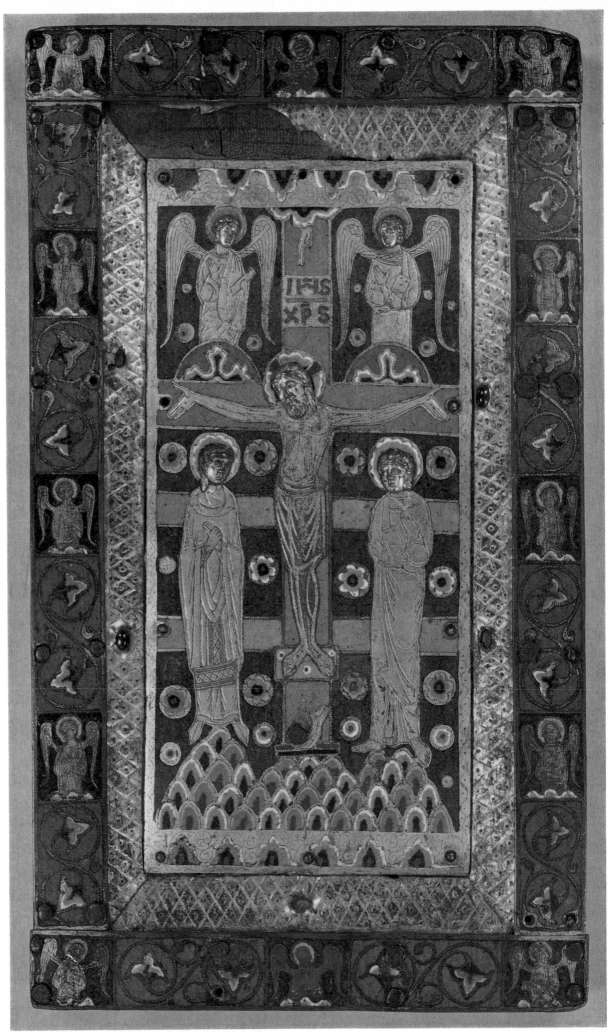

**PLATE 6** CAT. NO. 6

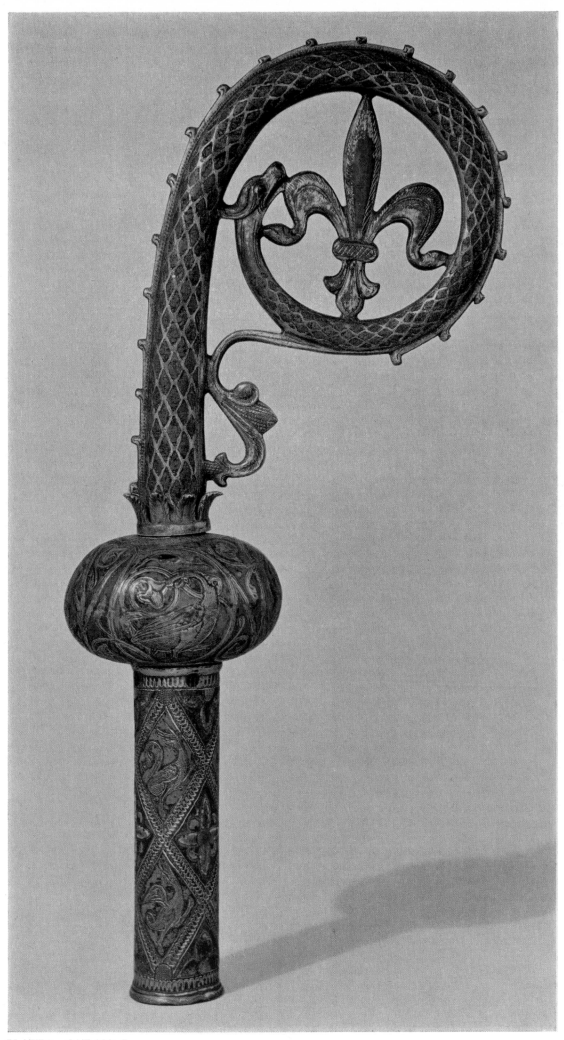

PLATE 7  CAT. NO. 7

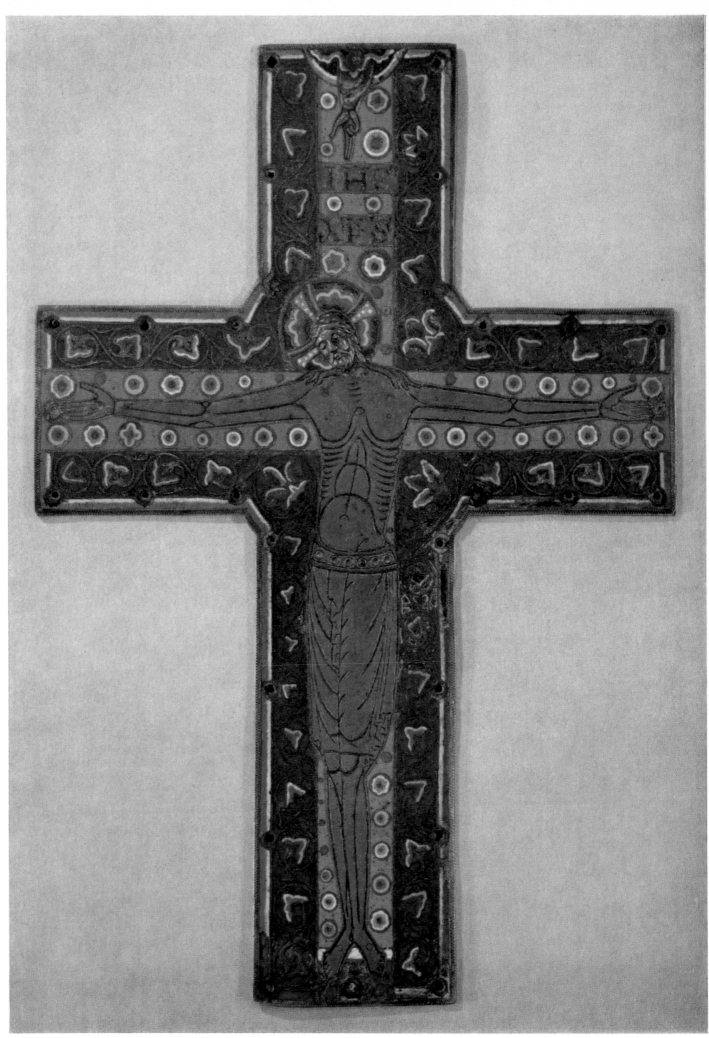

**PLATE 8** CAT. NO. 8

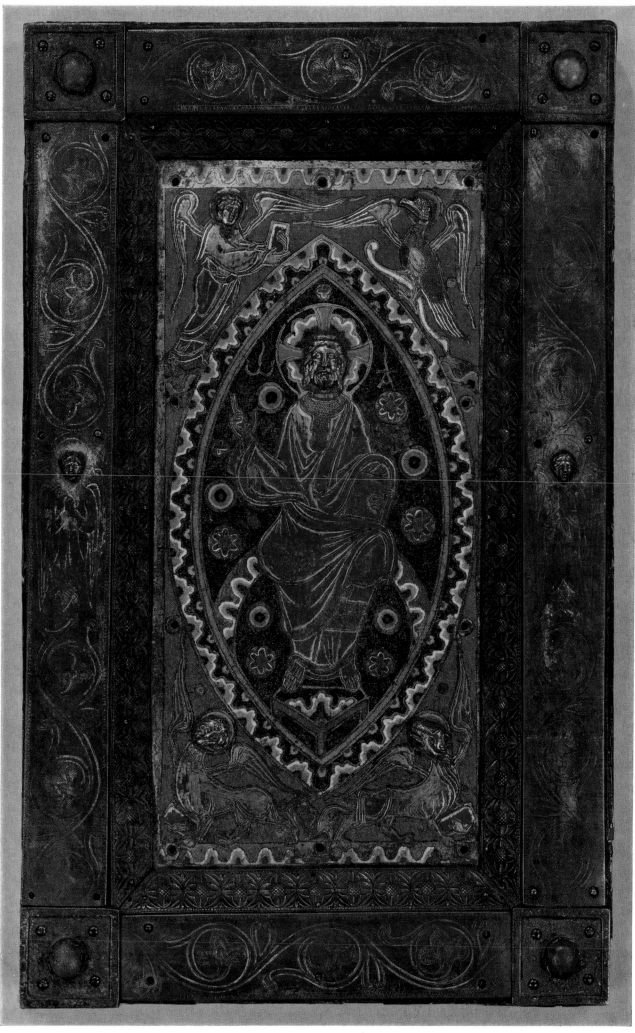

**PLATE 9** CAT NO. 9

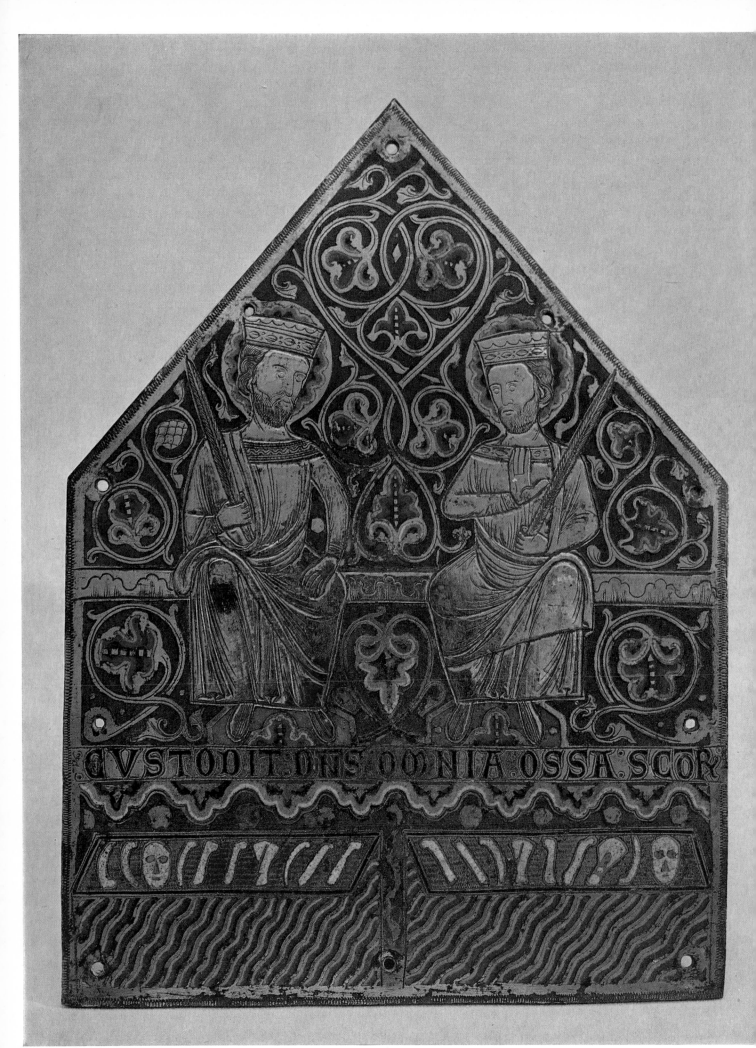

**PLATE 10   CAT. NO. 10**

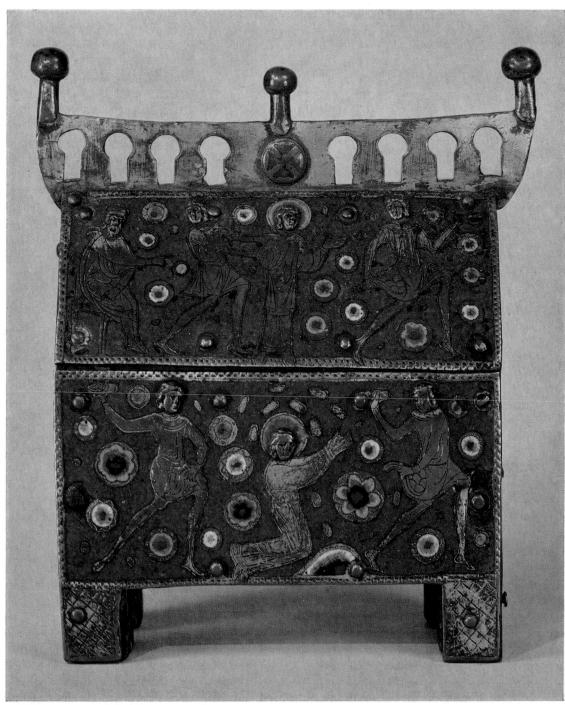

**PLATE 11** CAT. NO. 12

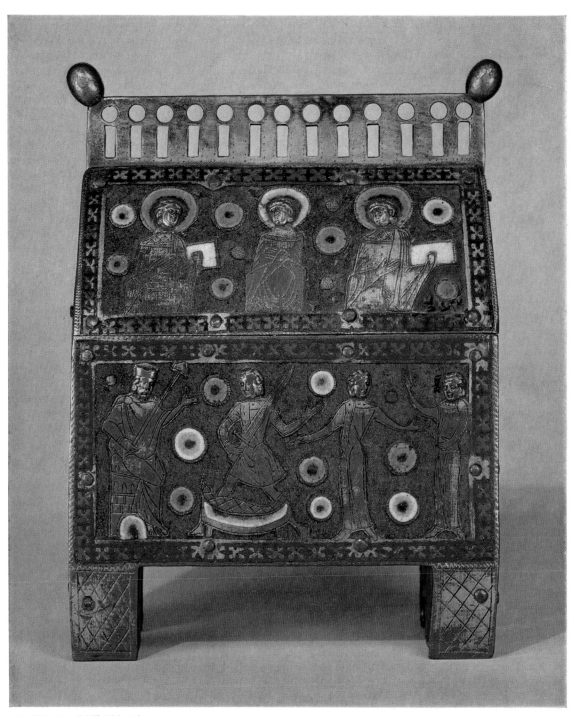

**PLATE 12**   CAT. NO. 13

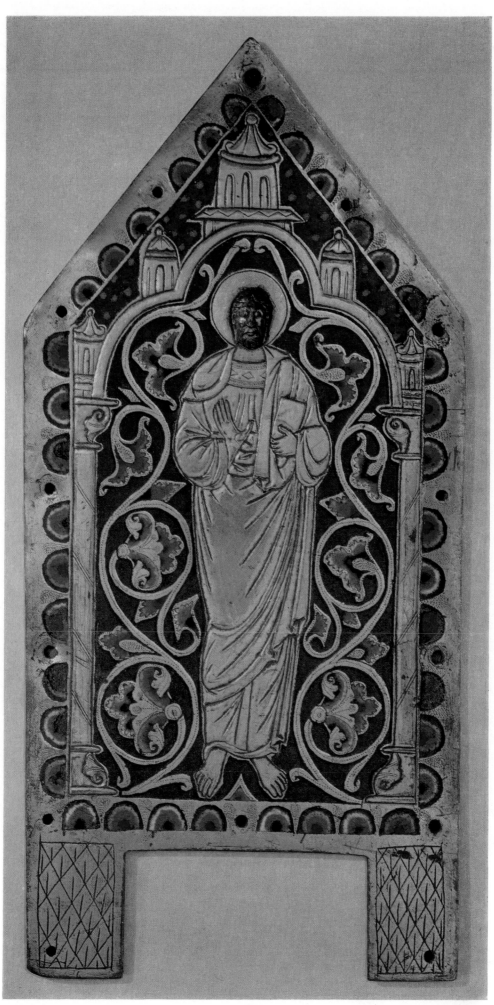

**PLATE 13**   CAT. NO. 15

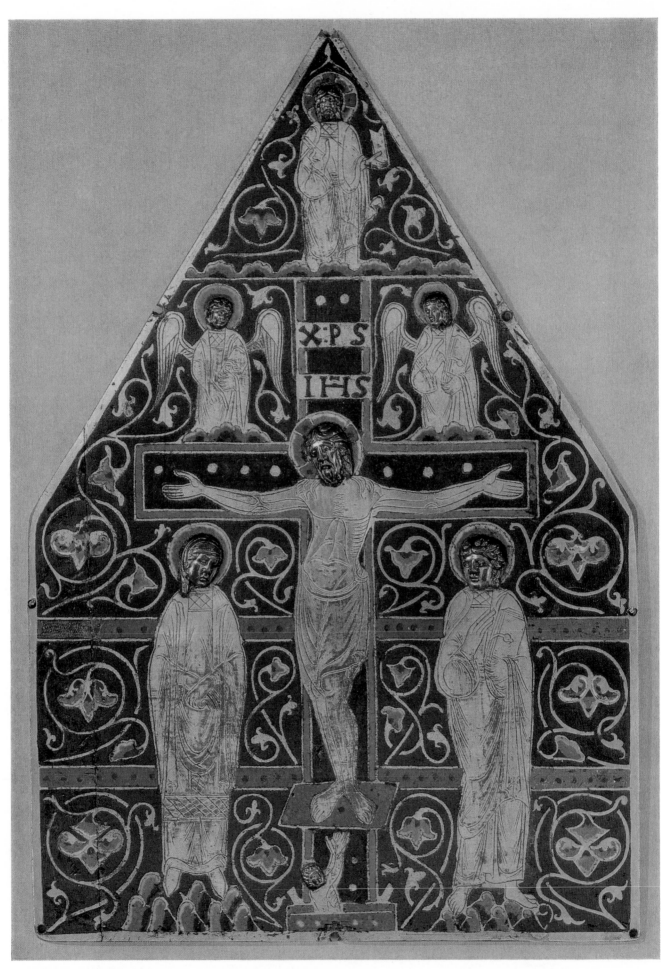

PLATE 14   CAT. NO. 16

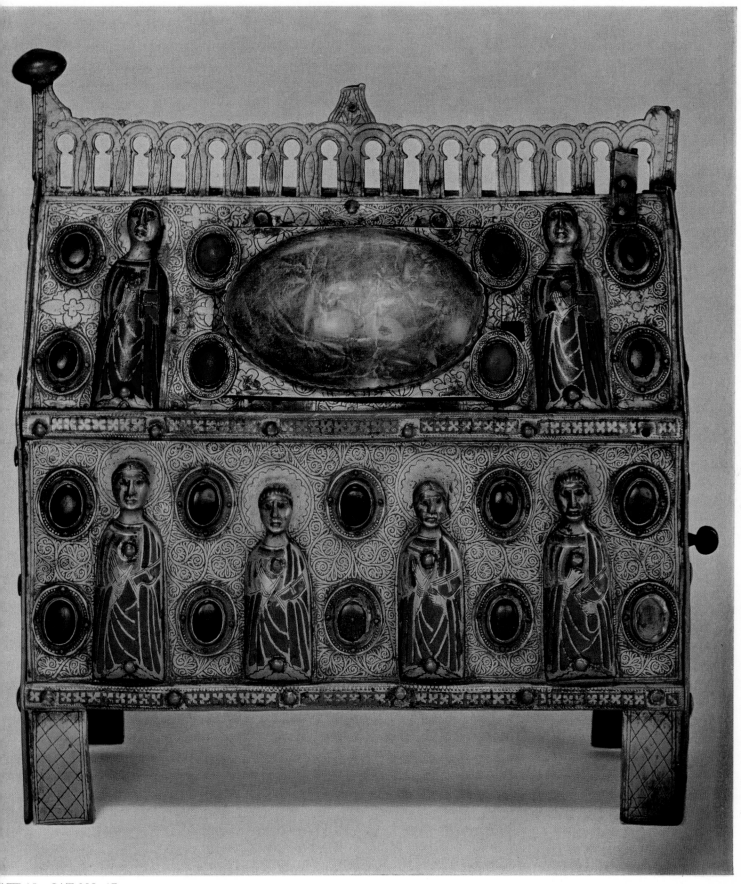

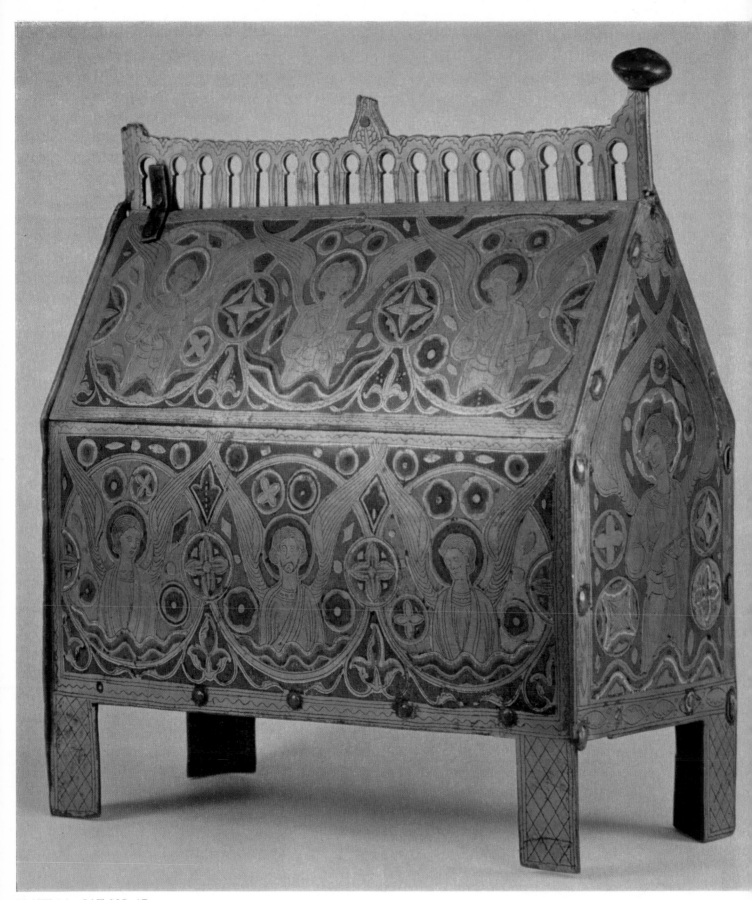

PLATE 16   CAT. NO. 17

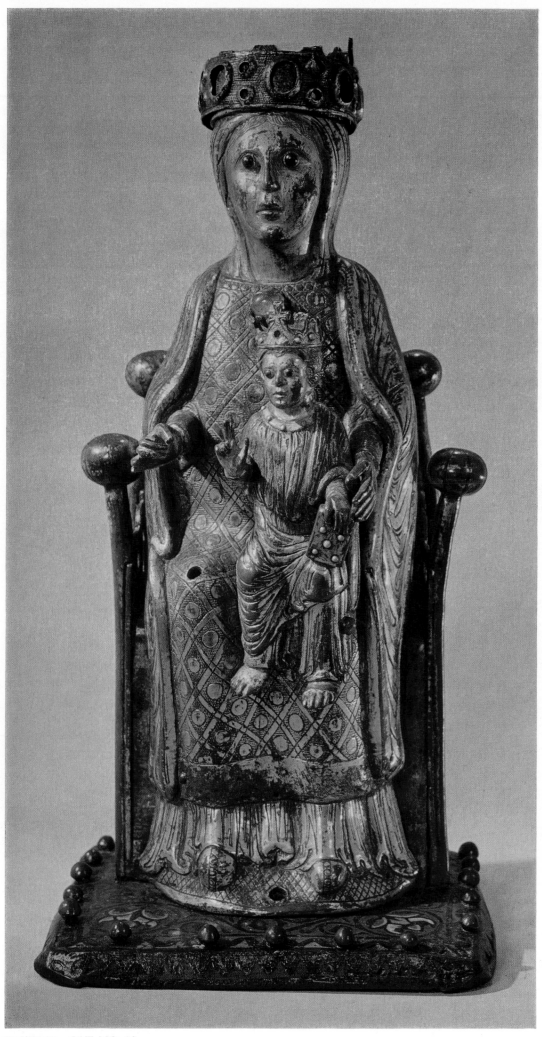

**PLATE 17** CAT. NO. 19

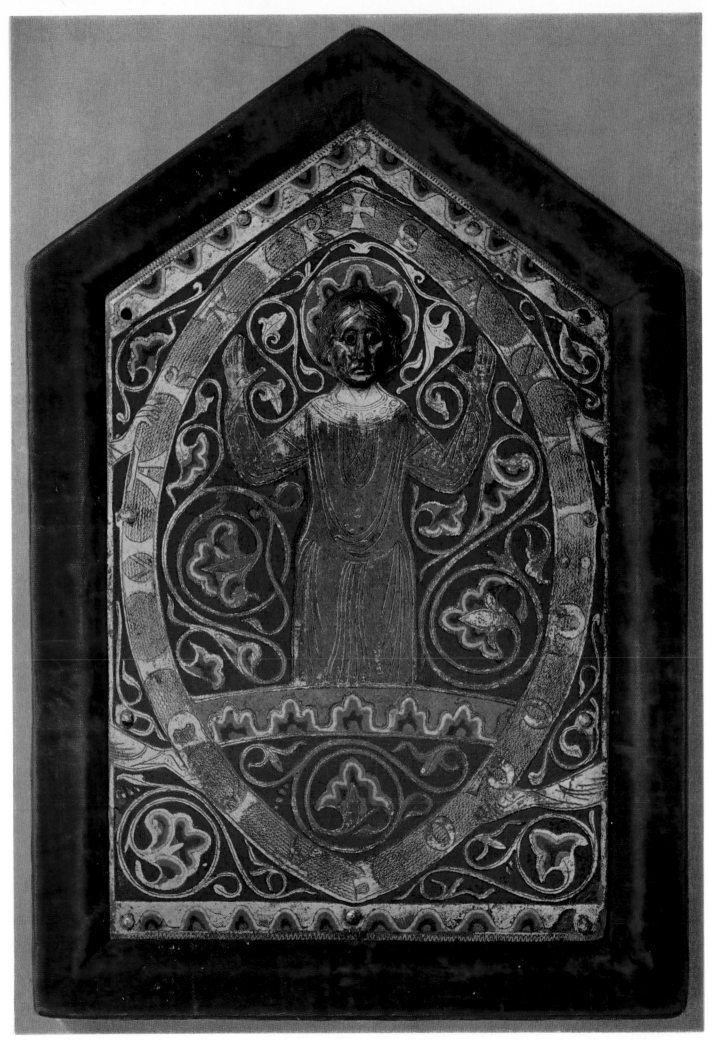

**PLATE 18** CAT. NO. 20

**PLATE 19**  CAT. NO. 22

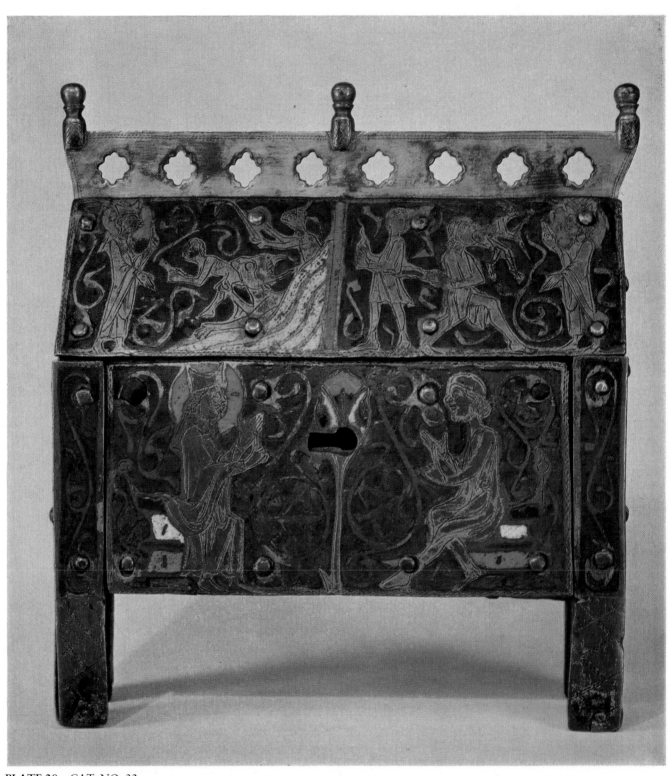

**PLATE 20  CAT. NO. 32**

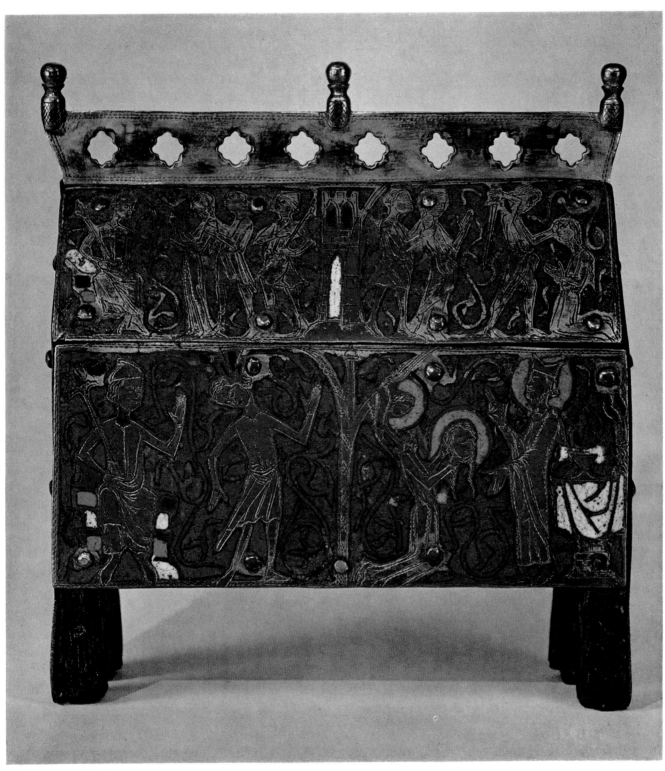

**PLATE 21** CAT. NO. 32

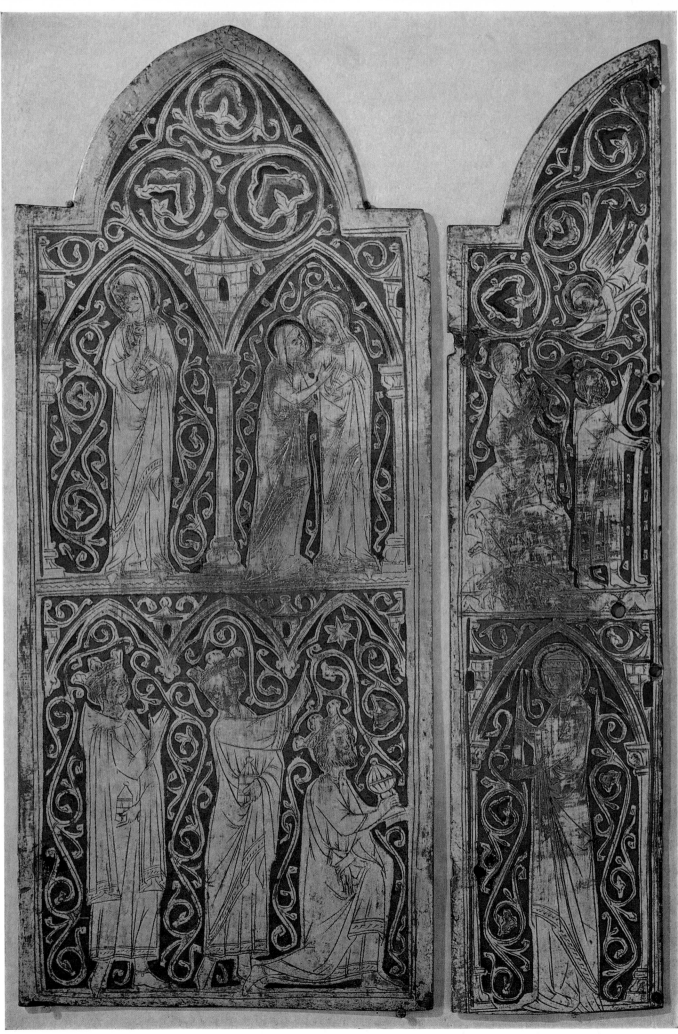

**PLATE 22**  CAT. NO. 37

PLATE 23

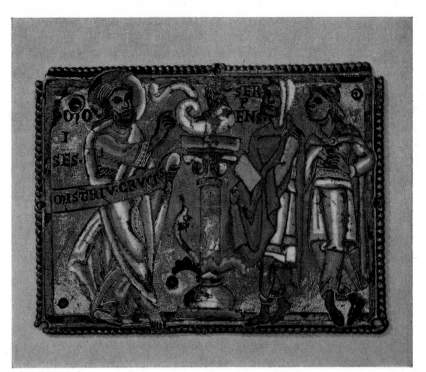

CAT. NO. 42

CAT. NO. 48

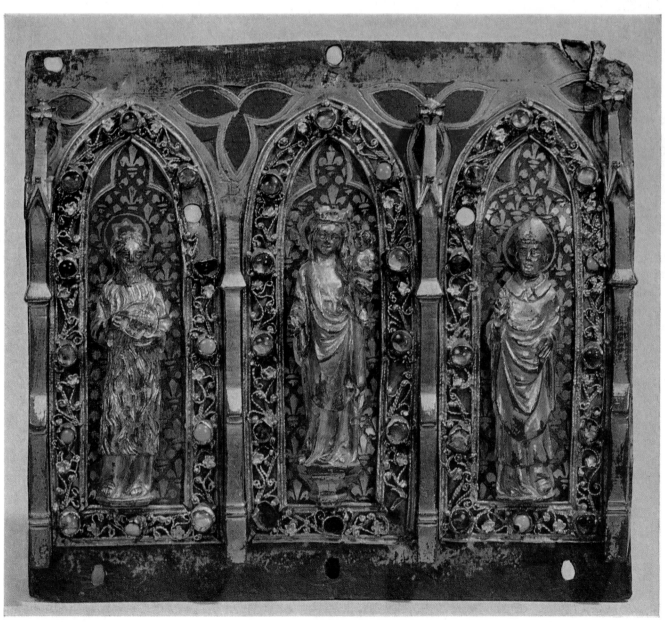

CAT. NO. 38

PLATE 24 CAT.NO.51

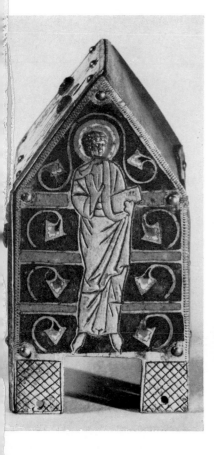
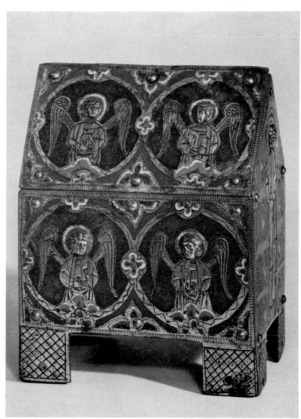
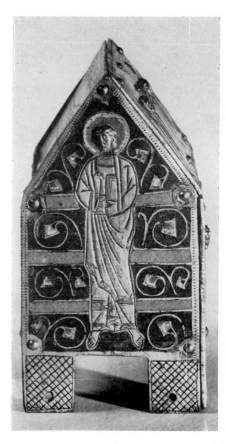
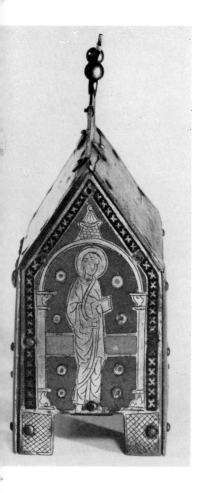
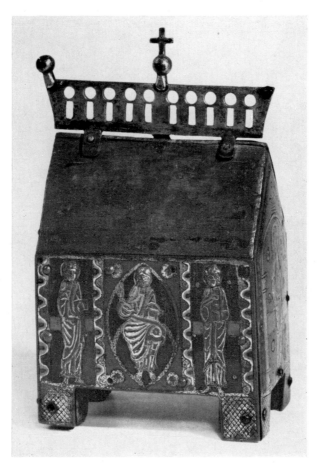
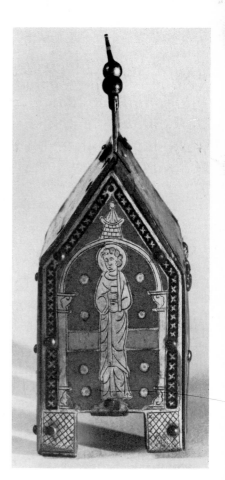

FIGURE 1

18

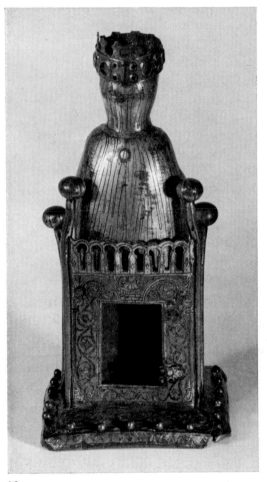

19

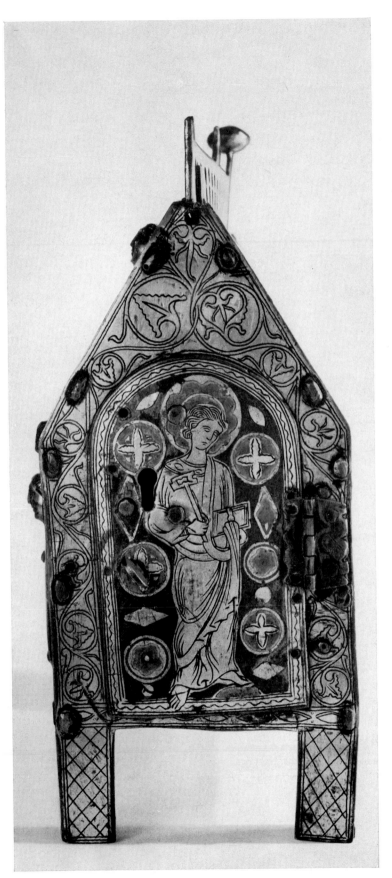

17

FIGURE 2

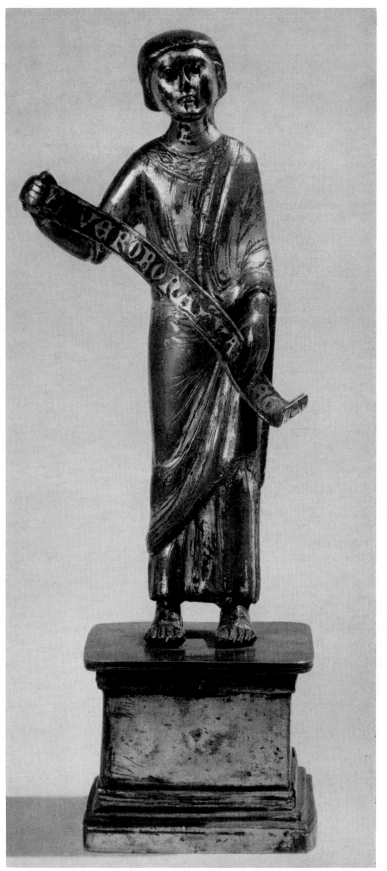

21

FIGURE 3

23

27

**FIGURE 4**

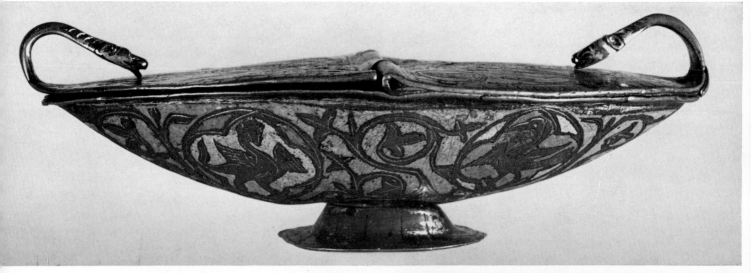

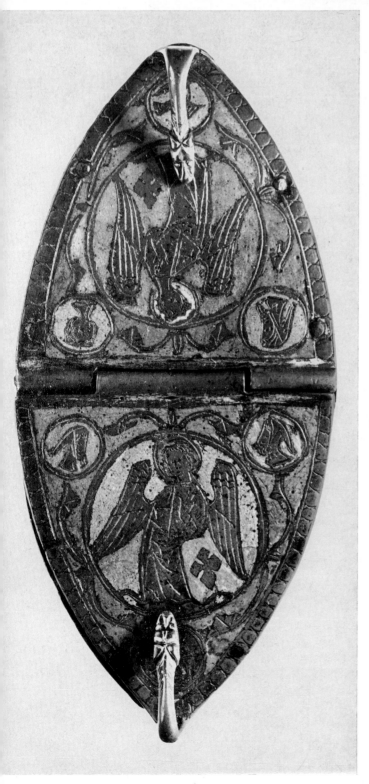

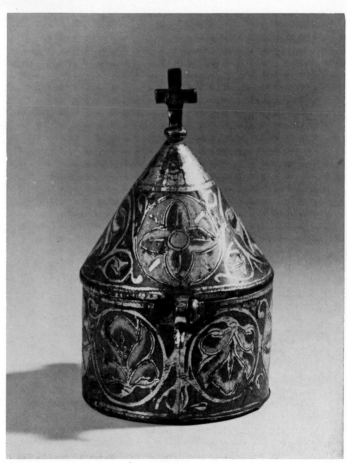

26

**FIGURE 5**

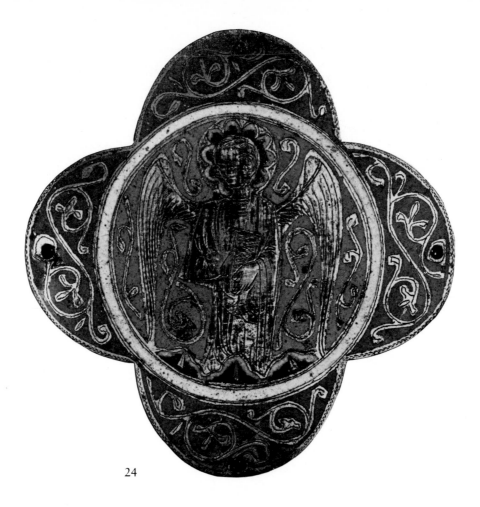

24

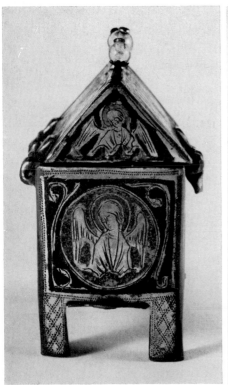

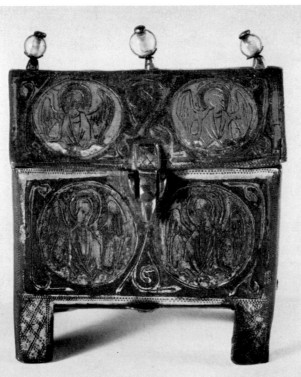

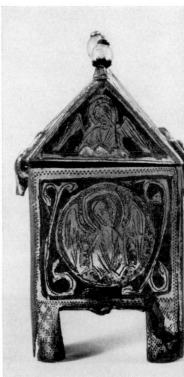

28

FIGURE 6

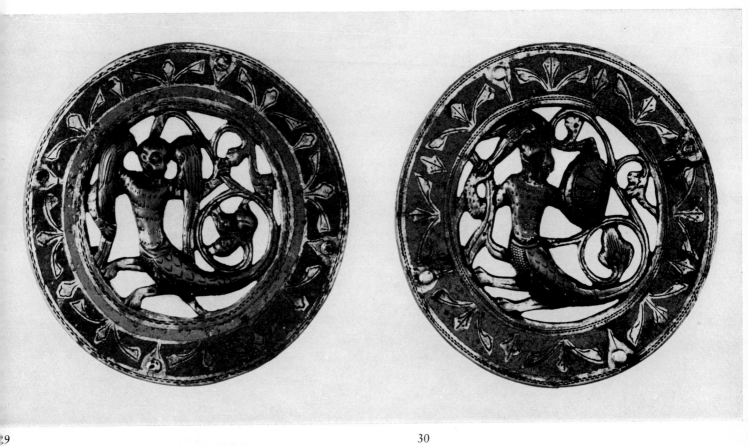

29                                         30

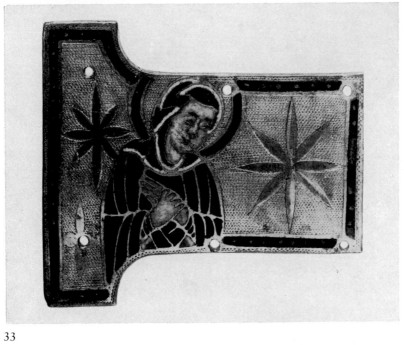

33

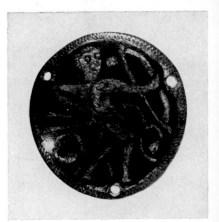

31

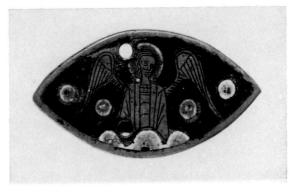

34

FIGURE 7

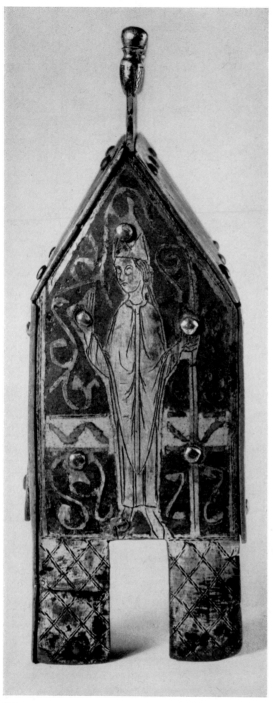

32

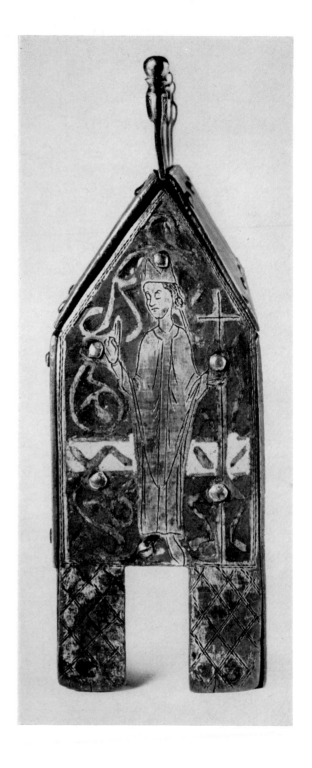

**FIGURE 8**

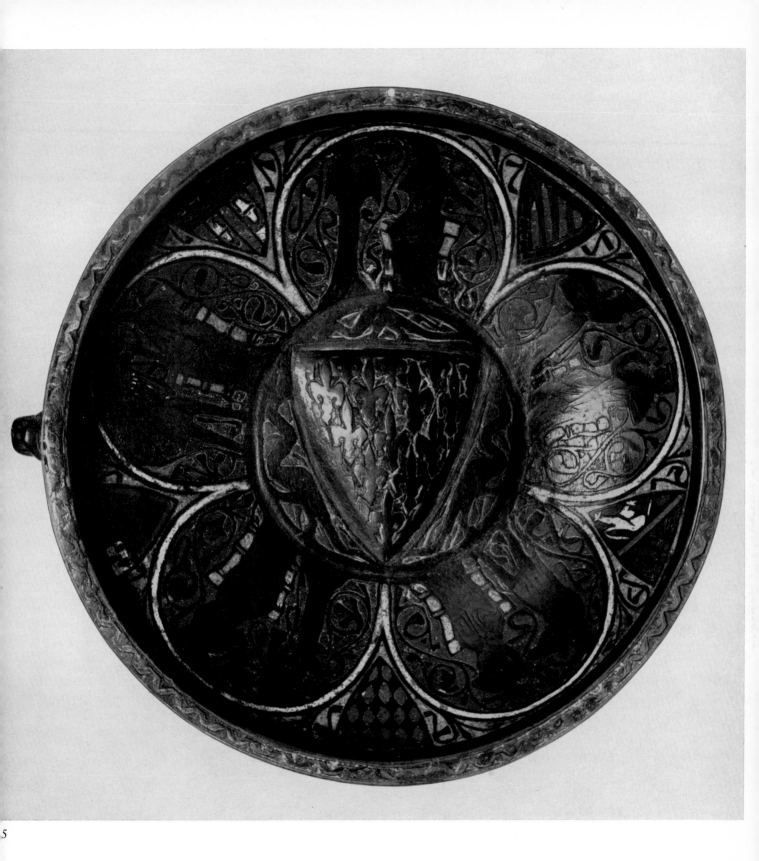

FIGURE 9

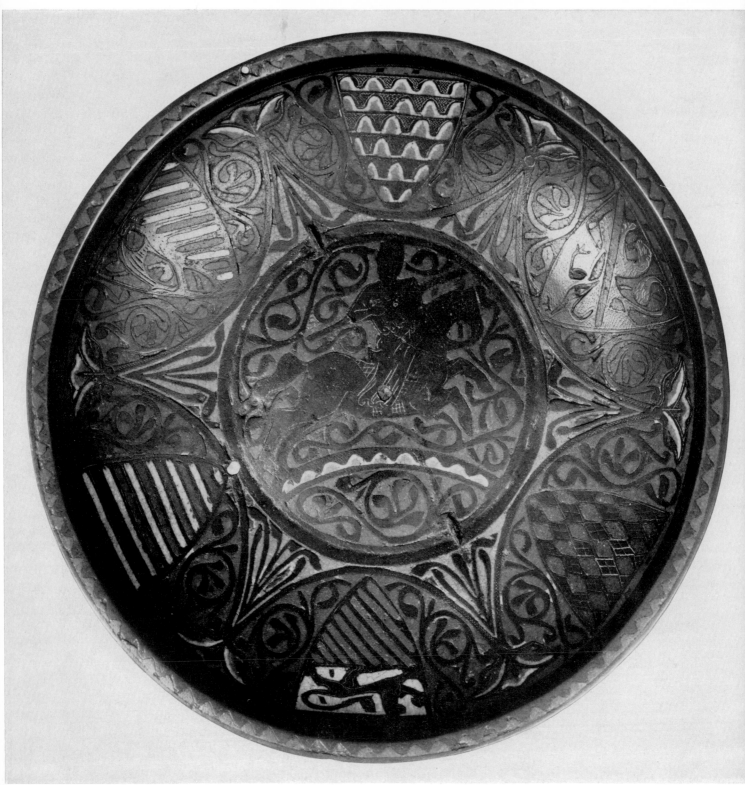

36

FIGURE 10

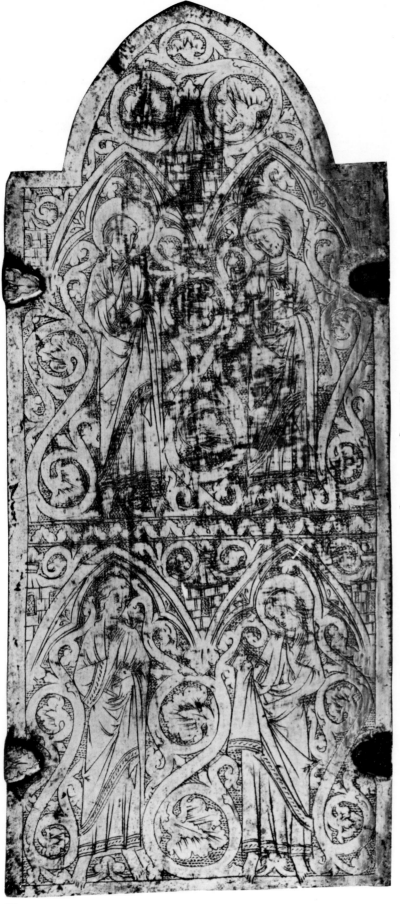

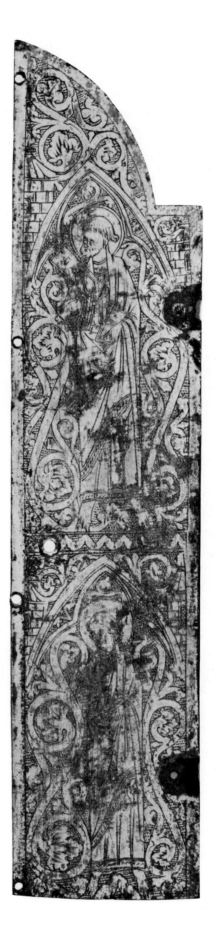

37

FIGURE 11

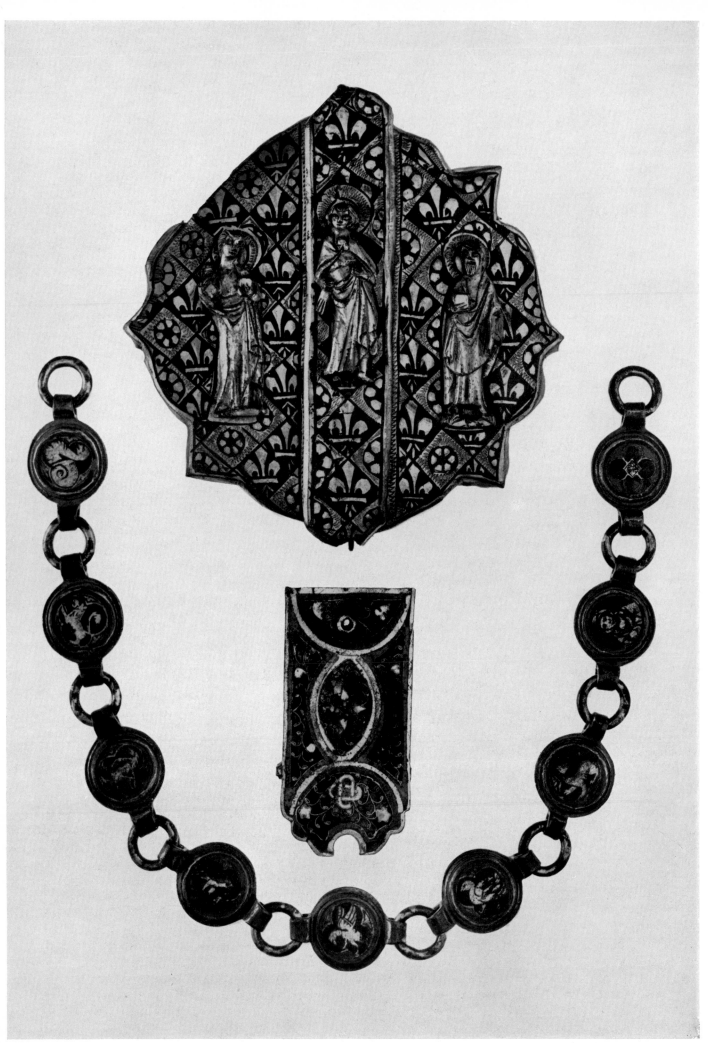

**FIGURE 12**    39, 45 and 54

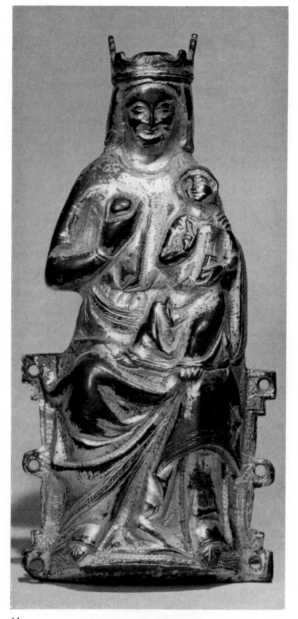

41

40

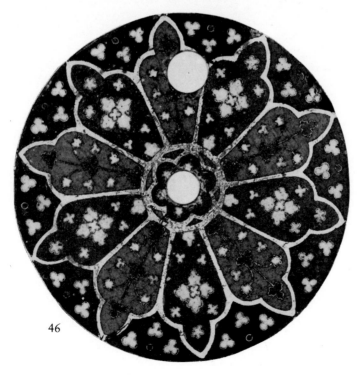

46

**FIGURE 13**

43

44

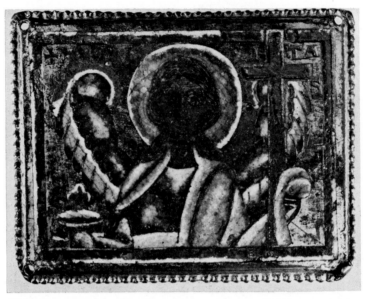

47

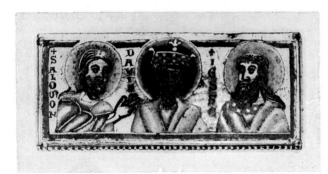

49

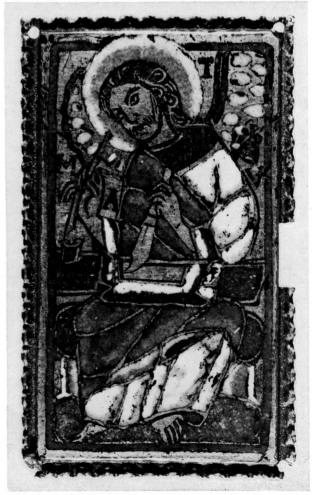

50

FIGURE 14

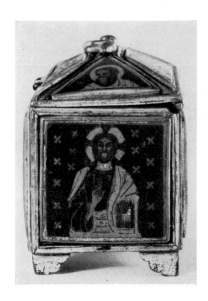 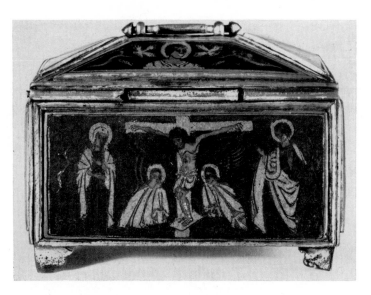

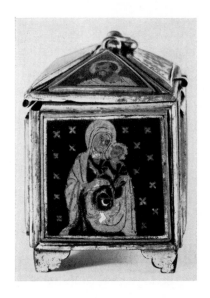 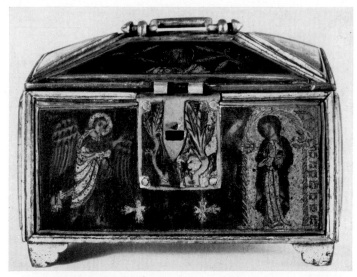

55

FIGURE 15

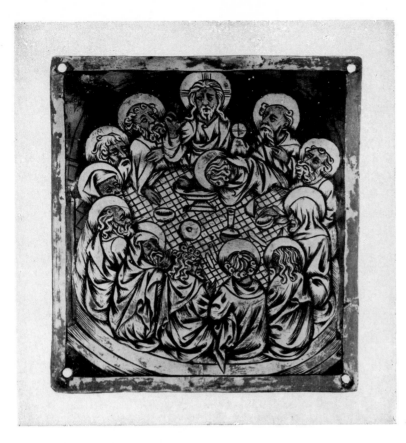

53

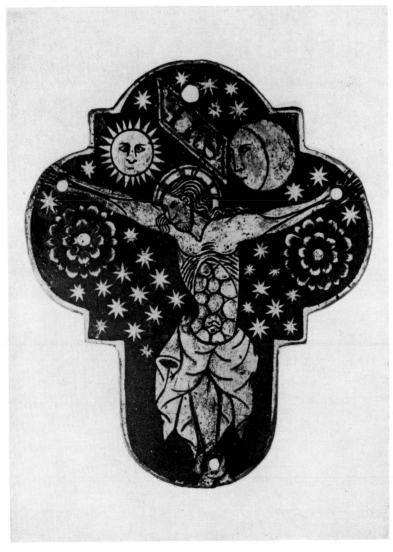

52

**FIGURE 16**